Understanding
Composition

THE EXPANDED GUIDE

T0317158

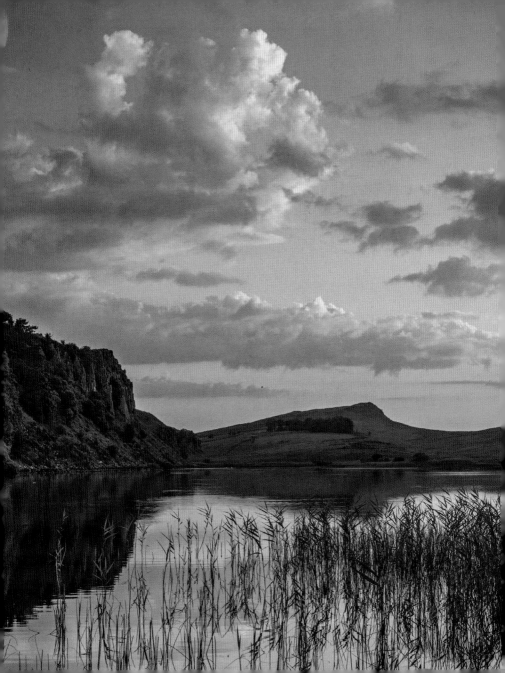

Understanding
Composition

THE EXPANDED GUIDE

David Taylor

AMMONITE
PRESS

First published 2014 by
Ammonite Press
an imprint of AE Publications Ltd
166 High Street, Lewes, East Sussex, BN7 1XU, United Kingdom

ISBN 978-1-78145-051-2

Editor: Chris Gatcum
Series Editor: Richard Wiles
Design: Belkys Smock

Typeset in Frutiger
Color reproduction by GMC Reprographics
Printed in China

(Page 2)
Summer sunset over Crag Lough,
Northumberland, United Kingdom.

CONTENTS

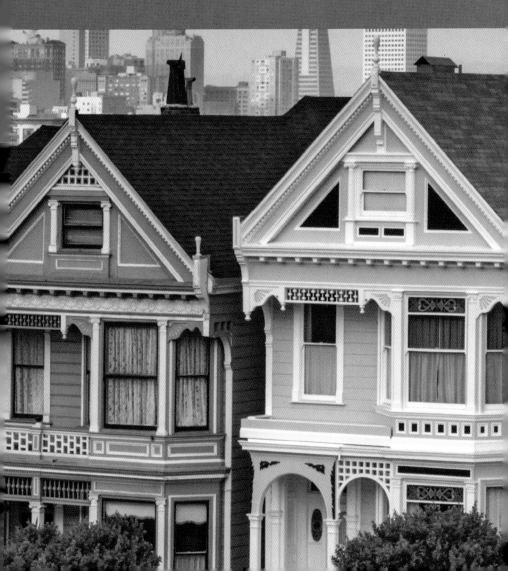

CHAPTER 1 INTRODUCTION

Introduction

Camera technology improves each year. However, despite increasing automation, one thing cameras can't do is compose an aesthetically pleasing image. This is still very much dependent on the photographer holding the camera.

What is composition?

Composition is the act of creating something new from other preexisting materials or elements. Composition can be applied to many different creative endeavors. Music is composed by arranging a series of notes in a pleasing or interesting way (what constitutes a pleasing piece of music is, of course, entirely subjective). Prose is composed by choosing words and ordering them into coherent and (hopefully) lively sentences.

Photographs are also said to be composed. This is often thought of purely in terms of how the various elements in a scene are arranged. For good reason, since this is indeed an important part of composing a photo. However, the success—or otherwise—of a photo is due to many other factors too. These include (but are not limited to) the quality of the light used and even the timing of when the photo was made.

A photo is only as good as its weakest part. A potentially interesting photo can be marred by neglecting one aspect during its making. This book will give you an overview of everything you need to think about before actually pressing the shutter button, and what can be done afterwards in postproduction to improve a photo.

TIMING
Photography—rather like music—often requires exquisite timing.

FRAMING *(Opposite)*
The arrangement of elements in a photo is an important part of successful composition, but not the only one by any means.

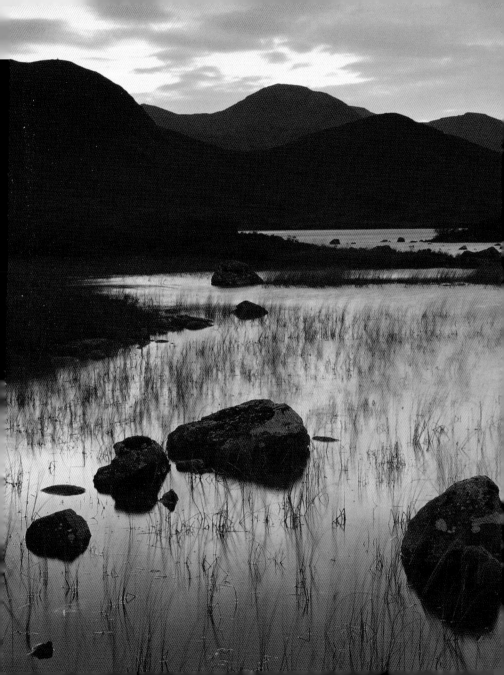

First steps

The composition of an image can be broken down into a number of steps. Mentally running through these steps before pressing the shutter button is a habit that will help save disappointment later.

Step 1: What should be in the image?

An image is an abstraction of reality. We don't see the world in a rectangular frame. Composing an image is an act of imposing order on the world, to fit it within the confines of the image space. The first step is therefore to choose what should fit within the boundaries of the image. Typically this will be the subject of the image, either filling the frame or shown in the context of its environment. The subject of an image can be as real as a person or a building, or as conceptual as a particular mood or abstract idea.

Step 2: What shouldn't be in the image?

Oddly enough, just as important as deciding what should be in an image is the decision about what shouldn't. This means being ruthless. Anything—whether it's a person or an inanimate object—that doesn't add to an image shouldn't be included. Something which appears to be an afterthought or is there purely by accident will detract from the main intent of your image. A pleasing image will work because it is a considered whole, with no elements to jar or distract (though there is nothing to stop you including elements that do jar or distract as long as that's your intention). There are several strategies for excluding elements. The main one is choosing the viewpoint. Often just shifting the camera's position slightly will make a big difference. The simplest way to change a viewpoint is to move the camera left or right.

EXCLUDED
This statue was in the middle of a cluttered and visually distracting urban environment. By selecting a low viewpoint, I was able to cut the clutter and simplify the image.

However, you should always consider making a vertical movement too. Finding a viewpoint above your subject so that you look down on it is a very effective way of simplifying your subject's surroundings. Looking up at your subject will have the same effect—particularly if this allows you to shoot it against a less distracting background, such as the sky. The lens you choose will also have a bearing on how well you are able to exclude distracting elements. Longer focal length lenses are generally easier in this regard. Wide-angle lenses often include too much. Arguably more care must be taken when composing with a wide-angle lens than with a telephoto.

Step 3: Where should my subject be in the image frame?
Where you place the subject in the image determines a number of factors. One of these factors is image balance. Another is the dynamic qualities of the image: does it feel static or energetic? We'll return to these factors in Chapter 3.

Step 4: How will a viewer's gaze wander through the image?
When we look at an image our eyes don't keep still. They're attracted to certain elements such as vibrant colors and areas of contrast. Strongly directional elements such as lines (whether real or implied) help to guide a viewer's gaze through an image. More negatively, elements that dissect an image can interrupt the flow of a viewer's gaze as effectively as a physical barrier.

A viewer's gaze ideally should remain within the image. Elements that direct the gaze out of the image will be distracting and make it feel somehow incomplete. Bright highlights act like visual magnets. This is acceptable if they're part of the subject, but less so if they're in the background and prove distracting.

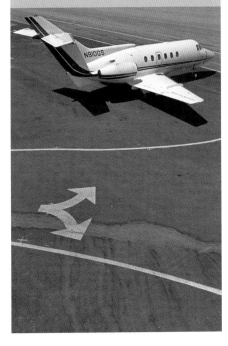

POSITION
This image is arguably a failure. There's no space around the aircraft and the composition feels too tight and restricted. There's nowhere for the eye to roam around.

Step 5: Am I holding my camera in the right orientation?

A vertical image has a different dynamic to a horizontal one. Deciding to shoot horizontally or vertically is an important aesthetic choice. Unfortunately, most cameras tend to sit more easily in the hand when held horizontally than vertically. However, you shouldn't allow this to be a deterrent.

Step 6: Is this the right time to make the picture?

Some images are very time-dependent: your subject may be moving and will only be in the right place for a split second; the sun may be in the wrong position; or there may be any number of other reasons. Therefore you need to think about whether this is the right moment to make an image or whether it would be improved by waiting.

Step 7: Is this the right light for my subject?

There is no such thing as good light, only light that is right for your subject. The light you use determines a number of different factors that could enhance or detract from your subject. The direction of the light will have an effect on where the shadows are in relation to your subject. This will also have an effect on how three-dimensional your subject will look in the image. The softness or hardness of the light affects the density and sharpness of the shadows. Finally, the color of the light has a big impact on the emotional impact of your image. There's more information about the various qualities of light in Chapter 4.

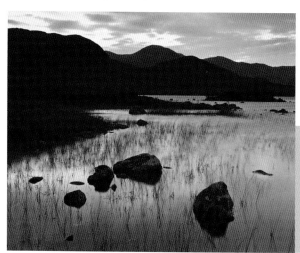

ORIENTATION
The orientation of your camera is an important consideration when composing a shot. Compare this to the vertical composition at the start of the chapter. Do they have a different feel?

Understanding Composition

Canon EOS 5D,
50mm lens, 1/4
sec. at f/18, ISO
100, Aperture
priority mode, spot
metering

CHANCE

Although image previsualization is a useful skill to learn, it's still important to allow chance a look-in occasionally. This image was found coming around a corner on a walk. There wasn't time to plan as the cloud was quickly dissipating.

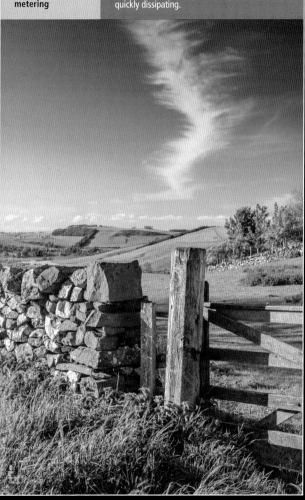

Preparing the mind

Making pleasing photographic compositions isn't an ability that only a select few can master. Anyone can be a creative photographer with patience and dedication.

Slowing down

There's a lot to be said for taking photography at a slow pace, particularly when learning the art of composition. In many ways composition is a lot like working out a puzzle. You need to take the three-dimensional world and fit it into a box, arranged in such a way that it makes perfect sense as a two-dimensional image. This requires a lot of visual processing by the brain. There are some people who can do all this in a split second, seemingly without conscious thought. The rest of us have to work at it. "Snapping" just doesn't give the brain time to figure out the composition puzzle, therefore it's worth setting plenty of time aside for your photography sessions. This extra time should be used to look at and assess thoroughly the compositional possibilities before setting up your camera. This is preferable to randomly shooting tens or hundreds of images in the hope that one of them will work. Quality rather than quantity is ultimately more satisfying.

ARRIVE EARLY
I always try to arrive at least half an hour early for an event such as sunrise, particularly if I'm going somewhere unfamiliar. This allows me time to scout the locations and work out the images I want to shoot without rushing.

Practice makes perfect

Figuring out the composition puzzle does get easier and quicker with practice. This is mainly to do with becoming more familiar with your equipment, particularly the angle of view of your lenses. After a while it becomes possible to previsualize a scene and know exactly what focal length is necessary to achieve the desired result. The only problem with practice is that it takes time. It also, if you're doing it right, generates a lot of images that then need to be edited and processed. This again takes precious time.

One surprisingly effective way to practice composing images is to carry a piece of card around with you. This piece of card should have a hole cut into it that is the same size and shape as the sensor in your camera (*see the table on page 25*). If you hold the card at the same distance away from your eye as the focal length of a lens for your camera, you'll see exactly what you'd see using that lens. For example, if the hole was 36 x 24mm (the same size as the sensor in a full-frame camera) and the card was held 50mm from the eye, the angle of view would be the same as a 50mm lens. The benefits of practicing in this way are that it can be done during an idle moment and that it encourages you to be always on the lookout for potential images.

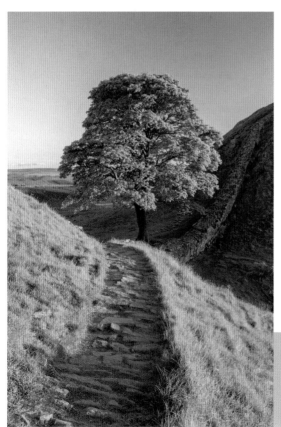

FAMILIARITY
I frequently use a 35mm prime lens and so can "see" shots that suit that focal length more easily than other focal lengths.

Viewfinders and Live View

Successful composition involves looking critically at the entire viewfinder or LCD before you press the shutter button.

A successful image is one that's a pleasing whole. The first time this is assessed is when you look at your camera's viewfinder or LCD. When first starting out in photography many people look only at the center of the viewfinder and forget (or don't realize) that there's more to an image than this. Assessing whether a composition has worked means looking not just at the center, but around the edges too—in fact, particularly around the edges. It's all too easy for something unwelcome to creep into the image space without your realizing.

Optical

Unfortunately, seeing the entire image is often easier said than done. There are cameras that show you a 100% view in an optical viewfinder (OVF), but these tend to be at the "professional" end of a manufacturer's camera range. More common are OVFs that show you a 95–98% view. Fortunately, losing 2–5% of the actual view isn't too drastic a problem and there are workarounds. One solution—if you have a zoom lens—is to compose and then, ever so slightly, zoom in. Another solution is to crop the image in postproduction to the view that you saw originally. Alternatively, you could make a final check by switching to Live View, which will usually show you a 100% view.

Note

Cameras that have an electronic viewfinder (or EVF) show a Live View image exactly the same as that shown on the rear LCD. This image is usually shown at 100% view too, unlike most OVFs.

CROPPED
You'd see the image inside the white box when looking at a viewfinder that showed 95% of a scene. However, the camera would shoot everything outside the box too.

Electronic

Live View has its problems too, however. Many Live View displays are cluttered with icons and shooting information by default. This will obscure important details that can be overlooked. Some of this information is useful before you make your image. When composing, however, it should be switched off so that you see the Live View image unimpeded.

LCD screens can also be difficult to see in bright light. Before making a composition decision you should try to shade the LCD as best you can (particularly if the LCD is the only method you have of composing an image). There are commercial shades for LCDs that are effective in reducing glare on the screen. However, it's easy enough to make your own out of stiff card. All you have to do is make an open-ended box, with the base slightly larger than the size of your camera's LCD.

Alternatively, a black cloth draped over your camera will work just as well, which you would then duck under. Rather fittingly, this resembles the hood of a view camera, the glass focusing screen of which needs shading for similar reasons.

One excellent feature that is generally available in Live View is a grid overlay. The most common grid type is one that dissects the screen with two sets of equally-spaced horizontal and vertical lines. This is helpful when composing using the "Rule of Thirds" described in Chapter 3. Grids are also useful for checking that horizontal or vertical lines within the image are straight. One example when this is invaluable is when shooting bodies of water. A visual check that the horizon is level at the time of shooting will save precious time in postproduction.

CLUTTERED
With every possible icon switched to visible, LCDs can become cluttered and visually distracting.

Composed

A successful photo requires the balancing of a number of different factors. This photo—although just a handheld "snapshot"—still required me to think about which lens focal length to select, which combination of shutter speed, aperture, and ISO to use, and which white balance preset was required.

Nikon D600, 35mm lens, 1/100 sec. at f/5, ISO 100, Aperture priority mode, Spot metering

Visualized

One of the key skills it's necessary to learn is visualizing what you want the final photo to look like before you press the shutter button. This involves experimentation and practice so that you understand what your camera equipment is capable of.

Nikon D600, 100mm macro lens, 1/400 sec. at f/8, ISO 160, Aperture priority mode, Evaluative metering

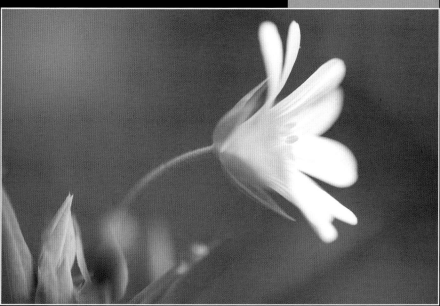

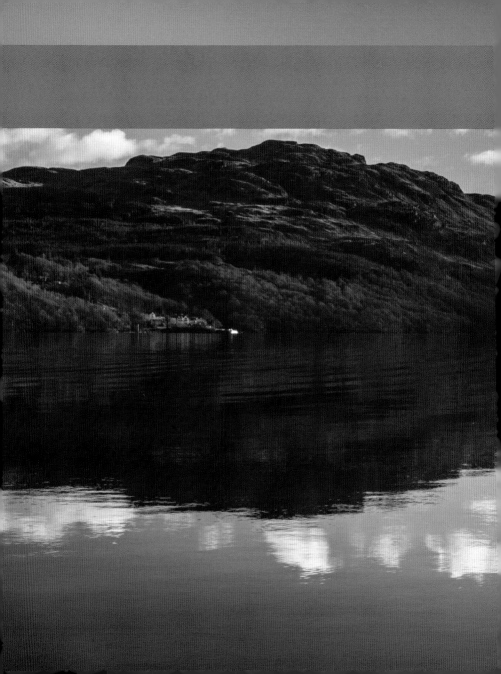

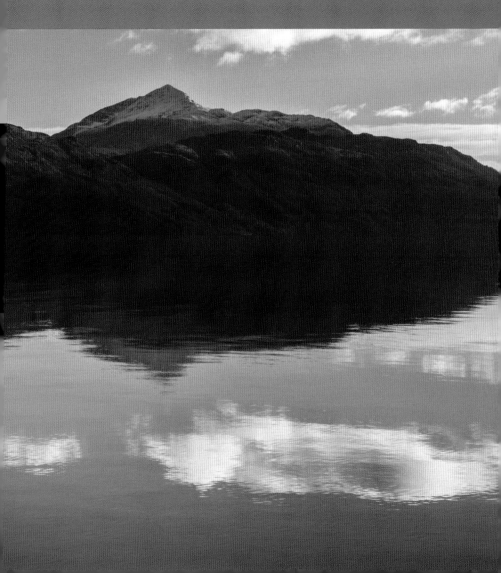

CHAPTER 2 EQUIPMENT

Equipment

It won't come as a surprise to you that photography requires the use of a camera in one form or another. However, your choice of camera and lenses will have an effect on your thought processes when making images.

Choices

It's often said that the camera doesn't matter—it's the person behind it who's important. To a certain extent this is true. All cameras are tools and they can be used well or they can be used badly. A good photographer will be able to create interesting images no matter how basic the equipment they use. However, cameras are important. If you don't like the ergonomics of a camera you're unlikely to want to use it. Ultimately getting the best out of a camera means using it as often as possible and understanding how well (or otherwise) it works in different shooting situations.

Cameras also have a subtle effect that's little appreciated. They can change how you see the world. You're unlikely to shoot the same type of image with a cell phone as you would with a fully-featured system camera. This is because you unconsciously adjust your photographic vision to suit the camera. Switching between different types of camera is an interesting and challenging way of expanding your creative potential.

NIKON 1 J3
Compact cameras are fun to use. I tend to be more experimental with them than I would with my main system camera.
Image © Nikon

TOY CAMERA (*Opposite*)
This image was shot on a Holga "toy" camera. The limitations of the lens forced me to compose in a way that I'd normally avoid.

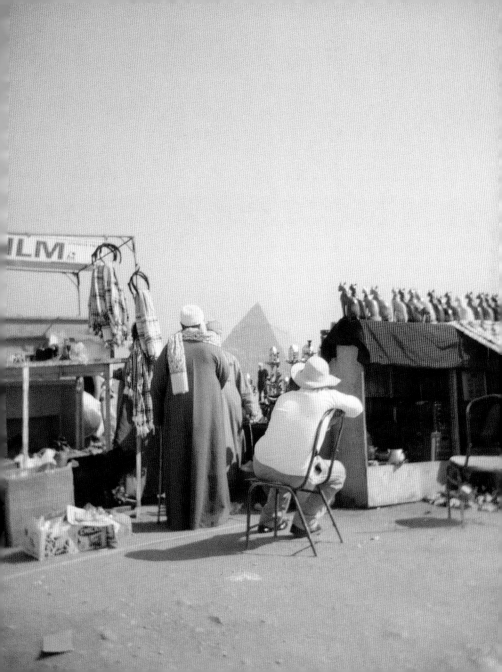

Digital sensors

Although digital cameras are alike in theory, there are important differences between individual models. The greatest difference is arguably in the size of the sensor inside the camera.

Size matters

Digital sensors are fabricated on disks of silicon. The smaller the sensor, the greater the number that can be fitted onto one disk. Small sensors are therefore less expensive to make than larger ones. In an ideal world we'd all be using inexpensive cameras with tiny sensors. However, reducing the size of a sensor has unavoidable consequences.

The first consequence is that image quality is often compromised. Photons of light are essentially units of information to a digital sensor. The greater the number of photons a digital sensor can sample during an exposure, the more information it will have to enable it to create an accurate image afterwards. A smaller sensor will always struggle to achieve this aim compared to a larger sensor. Cameras with smaller sensors are more prone to image noise, suffer from a restricted ISO range, and often have a compromised dynamic range too. In many respects using a camera with a smaller sensor is more difficult than using one with a larger sensor. More care has to be taken with exposure as there is generally less scope for adjustment in postproduction without image quality deteriorating unacceptably.

The "standard" sensor size is known as "full-frame" and is based on the dimensions of a 35mm film image. However, smaller sensor sizes are more common, with APS-C frequently used in less expensive system cameras and 1/1.7-inch sensors in compact cameras. Another consequence of sensor size is that the field of view of a lens is altered (often referred to as the "crop factor"). This is described later in this chapter, in the lenses section.

APS-C
Canon APS-C CMOS digital sensor.
© Canon

Common sensor sizes

Sensor size (inches)	Height (mm)	Width (mm)	Diagonal (mm)	Crop factor*
1/4 (iPhone 3)	2.4	3.2	4	10.8x
1/3.2 (iPhone 5)	3.4	4.5	5.7	7.6x
1/3	3.6	4.8	6	7.2x
1/2.7	4	5.4	6.7	6.4x
1/2.5	4.3	5.8	7.1	6x
1/2.3 (Pentax Q)	4.5	6.2	7.7	5.6x
1/2	4.8	6.4	8	5.4x
1/1.8	5.3	7.2	8.9	4.8x
1/1.7 (Canon G15)	5.7	7.6	9.5	4.5x
1/1.6	6	8	10	4.3x
2/3 (FujiFilm X20)	6.6	8.8	11	3.9x
1/1.2	8	10.7	13.3	3.2x
Nikon CX standard	8.8	13.2	15.9	2.7x
1	9.6	12.8	16	2.7x
Four Thirds / Micro Four Thirds	13	17.3	21.6	2x
1.5	14	18.7	23.4	1.8x
APS-C (Canon)	14.8	22.2	26.7	1.6x
APS-C (Nikon DX, Sony etc.)	15.6	23.6	28.3	1.5x
APS-H (Canon)	18.6	27.9	33.5	1.3x
35mm / full-frame	24	36	43.2	1x
Pentax 645D	33	44	55	0.8x
Digital medium format	40.2	53.7	67	0.6x
Phase One digital backs	40.4	53.9	67.4	0.6x

* Compared to a full-frame sensor.

Aspect ratio

Sensors don't just differ in size, they also differ in shape or, more specifically, their aspect ratio. Aspect ratio defines the proportional relationship of the horizontal size of a rectangle to its vertical size. A rectangle with an aspect ratio of 1:1 has horizontal and vertical dimensions that are proportionally equal: in other words, a square. There are no digital sensors that are currently made with an aspect ratio of 1:1, though it was a popular shape for medium-format film cameras, notably those produced by Hasselblad.

Digital system cameras typically use sensors with an aspect ratio of 3:2, which is a relatively long rectangle. The Four Thirds camera system, however, uses sensors with a 4:3 aspect ratio

(hence the name). This is a far squarer rectangle and is the same aspect ratio as an analog TV (it's also closer in shape to the 4x5 and 6x7 film standards than 3:2). If you regularly shoot movies with your camera you'll also encounter 16:9. This is the standard aspect ratio of HD TV and is a semipanoramic shape.

Learning to work within a particular image shape is one of the keys to successful composition. However, you don't have to be tied to the aspect ratio of your camera's sensor. Many cameras offer a crop facility (typically in JPEG file format only) or grid lines so that you can compose a shot with the intention of cropping later in postproduction (see Chapter 6).

ASPECT RATIO
This 3:2 image could be cropped to a 1:1 aspect ratio (the red box), 4:3 (green) or 16:9 (blue). Get into the habit of visualizing how an image should be cropped at the time of shooting, rather than as a way of later "rescuing" an image that you feel hasn't worked otherwise.

Camera types

There is a confusing number of digital cameras on the market today. Fortunately they can be split into a smaller number of simple categories.

Cell phones

There probably isn't a cell phone currently produced that doesn't have even a rudimentary built-in camera. The quality of the images varies a lot. Early phones produced images that were crude and low-resolution, with little or no control over exposure. More modern phones now rival inexpensive compact cameras for image quality (sales of compact cameras have declined recently, possibly for that very reason). Smart phones, such as Apple's iPhone series, produce very high-quality images indeed. Smart phones also enable the downloading of apps to the phone that can be used to manipulate images, allowing the photographer to alter images to suit their taste.

Advantages

There's a saying that the best camera in the world is the one you have with you when you need it. A cell phone is a camera that can be carried around all day and every day. There is a growing number of photojournalists who use cell phone cameras for that very reason. Another good reason is that a cell phone is discreet. A cell phone doesn't draw attention to itself in the way that a system camera would. Cell phones are ideal for street and documentary photography.

Disadvantages

Cameras can be built into cell phones because the imaging sensors used are very small. This involves a number of compromises. The most important is that low-light performance is usually poor compared to a compact or system camera. Cell phones tend to have fixed focal length lenses too. This means that the only way to "zoom" is to physically move the camera closer or further away from the subject.

MOBILE
Having a camera with you at all times encourages experimentation and spontaneity.

Compact and bridge cameras

Compact cameras have several defining features. The first is that they're... well, compact. This makes them easy to carry around, either in a pocket or small camera bag. The size is achieved through the use of a relatively small digital sensor: bigger than a sensor in a cell phone, smaller than one in a system camera. In terms of image quality and low light performance this places compact cameras somewhere in the middle ground. Compact cameras have a fixed lens (one that can't be removed to be swapped with another).

The range of features on a compact camera depends largely on price. Low-cost compact cameras are often quite feature-poor, though generally basic exposure control is possible. High-end compacts are often the equal of system cameras when it comes to features, offering a high level of control over the picture-making process.

Bridge cameras are so-called because they "bridge" the gap between compact and system cameras. They tend to be bigger and better-specified than compact cameras. An interesting recent trend has been the release of bridge cameras with lenses that sport an enormous optical zoom range (often referred to as superzooms). The record holder at the time of writing is the Panasonic Lumix DMC-FZ70, which features a zoom lens with a full-frame equivalent of 20–1200mm. Superzooms are an attractive option if you want a camera that can be used for just about any shooting situation you can think of.

Advantages

A compact camera is typically an "all-in-one" camera with a built-in lens and flash. The focal length of the lens varies from model to model, but a wide-angle to telephoto range is common (there are one or two compact cameras that have fixed focal length lenses, but these are unusual). Once you've charged the battery up, a compact camera is ready for use.

VIEWFINDER
The FujiFilm X20 is one of the few current compact cameras to feature an OVF.
Image © FujiFilm

Disadvantages

If you're used to a system camera, a compact camera will often feel sluggish in use. Autofocus is usually less rapid (and often more hesitant). Compact cameras also tend to suffer from shutter-lag too. There is often a noticeable pause after pressing the shutter button before the camera reacts.

Depth of field is typically greater on a compact camera than a system camera at equivalent focal lengths. This is an advantage when front-to-back sharpness is required, but a disadvantage when you want to use techniques such as differential focusing.

With very few exceptions, compact cameras don't have OVFs. This means that composing an image is achieved using the LCD. This can be a big problem in bright conditions.

The longer the focal length of a lens, the less practical it is to use. Although the lenses of superzooms are less weighty than their system counterparts, they are no easier to use at maximum zoom. The most difficult aspect of using a superzoom is keeping it steady. Any movement during exposure will be magnified, resulting in visible camera shake.

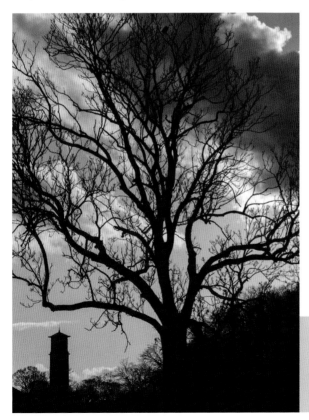

NOTEBOOK
I often use my compact camera as a visual "notebook" to record compositional ideas that can be repeated later with my larger "work" camera.

System cameras

System camera is a simple phrase, but it is more complex than it sounds. The simplest description is that a system camera is one that does not have a fixed lens—the lens can be removed and then swapped with another. However, the phrase covers a wide range of cameras that, at first glance, have very little in common. Arguably the most esoteric type of system camera is the view camera. Typically, these are film-based cameras with a glass focusing screen, a rail mechanism for focusing, with flexible bellows that maintain a light-tight seal between the focusing screen and the lens board. The basic design stretches back to the dawn of photography and hasn't changed much since. An interesting quirk of the view camera is that the image on the focusing screen is viewed upside down.

More common is the single-lens reflex or SLR camera. This type of camera uses an angled mirror to direct the image from the lens to the viewfinder via a pentaprism. When the shutter button is pressed the mirror swings up and out of the way (hence reflex), obscuring the viewfinder, but revealing the shutter. The shutter opens to make the exposure, then closes, and the mirror returns to its former position. The one big advantage for the photographer is that what is seen through the viewfinder is exactly what is captured at the moment of exposure. The basic concept of the SLR was invented in the late 19th century. The digital SLR or DSLR is the 21st-century refinement of this Victorian idea. Canon and Nikon are the two current giants of DSLR design and production.

DSLR
The Canon 70D, at the time of writing the latest DSLR in the Canon range.
Image © Canon

Another variant of the system camera is the rangefinder. Rangefinders also have optical viewfinders. However, the viewfinder is not connected to the lens so the photographer does not see quite what the camera "sees". This may sound slightly eccentric, but rangefinders do have their adherents. The viewfinder shows a wider angle of view than the lens, with frame lines in the viewfinder marking the extent of the lens' angle of view. This means that the photographer can see what will enter the image space before it actually does so. This makes anticipating action arguably far easier than when shooting with an SLR. For this reason rangefinders have long been the preferred option for street photographers. The downside of the rangefinder is that the range of available lenses is usually quite small due to the mechanics of displaying accurate frame lines in the viewfinder. Rangefinders typically don't allow the use of telephoto or extreme wide-angle lenses. Leica is the company most associated with the rangefinder, though in recent years Fujifilm have found a niche for themselves with their X Mount cameras.

To further complicate matters there are system cameras that don't have viewfinders, making do with a rear LCD only (sometimes an EVF is also available). This makes them neither an SLR (there is no mirror or pentaprism) nor a rangefinder. The Micro Four Thirds cameras produced by Olympus and Panasonic are good examples of this type of camera (the original Four Thirds system began life using the SLR model, but seems to have been abandoned). Finally, Sony has recently introduced their SLT range. These use a fixed translucent mirror rather than an opaque reflex type and an EVF rather than an OVF.

MICRO FOUR THIRDS
Panasonic Lumix G6, a Micro Four Thirds camera with an EVF.
Image © Panasonic

Nikon D600, 50mm, 1/1250 sec. at
f/3.5, ISO 400, Aperture priority mode,
evaluative metering

DEPTH OF FIELD

Another advantage of a system camera is the ability to fit fast
prime lenses. With their large apertures, these lenses allow
you to minimize depth of field very precisely. In this shot, by
the use of a large aperture and focusing on the foreground
flower stem, the background has been thrown out of focus.

Advantages

A system camera is one small part of a system that includes not only lenses, but also other accessories such as flashguns. This makes them very expandable. You can keep adding to and replacing your system as your photographic aspirations grow. The type of system camera you decide is right for you is very much a personal decision. The SLR type has the advantage of an OVF, which is still unsurpassed for clarity compared to an EVF. However, EVFs are arguably more accurate in that they show an image that resembles the final exposure accurately (often displaying a live histogram too, so that it's easier to see whether the shadows or highlights are clipping).

The sensors in system cameras are typically far larger than those in compact cameras. This means that image noise is less of an issue and dynamic range is generally greater. Depth of field is less for an equivalent lens than in compact cameras, which means that techniques such as differential focus are easier to achieve.

Disadvantages

System cameras by their very nature are far larger than compact cameras. This can make handling an issue, particularly when long focal length lenses are used. They are also not an all-in-one solution. Often multiple lenses are needed for separate tasks, adding to the size and weight of the system.

There are two focusing systems currently used on system cameras: phase detection and contrast detection. Neither system is perfect. Phase detection is faster, but marginally less accurate than contrast detection. Phase detection is more suited to fast action than contrast detection, though the technology of contrast detection is improving year on year. Typically cameras that have an OVF use phase detection. Cameras that use an EVF (or when switched to Live View) use contrast detection.

LEGACY
Some digital system cameras can still use lenses that are decades old and designed for film cameras. Pentax's K-mount cameras are a good example of this type.
Image © Pentax Ricoh

ERGONOMICS

In many ways a camera's ergonomics are as
important as its technical specifications. Ideally
important functions such as exposure control
should be readily accessible and easily adjusted.
It's frustrating to miss a shot because your
camera couldn't be made ready in time.

Lenses

A lens focuses light to create a sharp image. It also determines how much of a scene is captured, as well as the image magnification.

Focal length

The focal length of a lens is the distance in millimeters from the optical center of the lens to the focal plane when a subject at infinity is in focus. The camera's sensor is placed at the focal plane, the location of which is often shown by a ⊖ symbol. Slightly confusingly the focal length of a lens isn't necessarily its physical length, though typically the longer the focal length of a lens, the longer the lens. The focal length is one of two factors that determine the angle of view of the image projected onto the sensor, the other being the size of the sensor itself. The longer the focal length of the lens, the smaller the angle of view, but the more the projected image is magnified. The focal length of the lens also determines the depth of field available at a particular aperture. The longer the focal length, the less depth of field is achievable at a given aperture.

There are essentially two types of lens. There are those that have a fixed focal length, commonly referred to as primes, and there are lenses that allow you to alter the focal length, known as zooms.

ZOOM
Sony 70–400mm f/4–5.6 lens.
Image © Sony

Angle of view

The angle (or field) of view of a lens is the angular extent of the image projected by the lens onto the sensor. The angle of view of a lens is expressed in degrees (°) and refers to the horizontal, vertical, or diagonal coverage of the lens. If an angle of view figure for a lens is shown without stating which it's referring to, it will typically be the diagonal angle of view. The angle of view figure depends on the focal length of a lens and the size of the sensor that records the image projected by the lens. Lenses can be roughly divided into three groups: wide-angle, standard, and telephoto.

Horizontal lens angle of view and sensor size

Focal length	Sensor size							
	1/2.5in.	1/1.7in.	2/3in.	Nikon CX	Four Thirds	APS-C (1.5x)	APS-H	Full-frame
6mm	51°	65°	72°	96°	110°	126°	135°	143°
10mm	32°	42°	48°	67°	82°	99°	110°	122°
14mm	23°	30°	35°	51°	64°	80°	91°	105°
18mm	18°	24°	28°	41°	51°	66°	77°	90°
24mm	14°	18°	21°	31°	40°	52°	62°	74°
28mm	12°	16°	18°	27°	34°	46°	54°	65°
35mm	9°	12°	14°	22°	28°	37°	45°	54°
50mm	7°	9°	10°	15°	20°	27°	32°	40°
80mm	4°	5°	6°	10°	12°	17°	20°	25°
100mm	3°	4°	5°	8°	10°	13°	16°	20°
150mm	2.2°	3°	3.4°	5°	7°	9°	11°	14°
200mm	1.7°	2.2°	2.5°	4°	5°	7°	8°	10°
250mm	1.3°	1.7°	2°	3°	4°	5°	7°	8°
300mm	1.1°	1.5°	1.7°	2.5°	3.3°	4.5°	6°	7°
400mm	0.8°	1.1°	1.3°	2°	2.5°	3.4°	4°	5°
600mm	0.6°	0.7°	0.8°	1.3°	1.7°	2.3°	2.7°	3°

Numbers in gray indicate the approximate focal length for a standard lens for the sensor.

TWO LENSES (Opposite)
These images were shot from exactly the same position using a full-frame camera. The top image was shot with a 28mm lens (with an angle of view of 65°). The bottom image was shot with a 200mm lens (with an angle of view of 10°).

Wide-angle lenses

As the name suggests, wide-angle lenses have a wide angle of view. The most extreme example of this type is the fisheye lens, which has an angle of view of 180° (or more—leading to a lens that "sees" behind the camera). Another defining characteristic of the wide-angle lens is that spatial relationships between elements of a scene are extended and exaggerated: distant objects will seem smaller and further away than with the naked eye.

Wide-angle lenses create images that are arguably more involving for the viewer. It's easier to create a sense of depth with a wide-angle lens than with a telephoto. Images created with a wide-angle lens will have a foreground, mid-ground and background. The more restricted angle of view of a telephoto makes this more difficult to achieve. Wide-angle lenses also have inherently greater depth of field at a given aperture too. Front-to-back sharpness is less of a problem with a wide-angle lens than it is with a telephoto. The exaggeration of space can add drama to an image shot with a wide-angle lens. Any lines in an image, real or implied, will appear to recede more quickly than when shot with a longer lens.

ULTRA-WIDE
Very wide-angle lenses are useful when large subjects need to be squeezed into the image space. However, distortion at the extreme corners can be a problem.

Standard lenses

A standard lens is one that has a focal length that approximately matches the diagonal measurement of the camera's sensor. On a full-frame camera this is 43mm, though 50mm has become the default as 50mm primes are more commonly produced than 43mm lenses. On APS-C cameras the standard lens is closer to 28mm. See the table on page 36 for equivalent focal lengths for other sensor sizes.

The standard lens is often referred to as a normal lens. This is because images have a very natural look, with the spatial relationship of elements in the image similar to how they're perceived with the naked eye. This means that images created with a standard lens arguably don't have the impact of those shot with a wide-angle or telephoto lens. However, this is no bad thing. Documentary photographers often use standard lenses because this lack of visual impact is less likely to detract from the subject of the image.

Telephoto lenses

Telephoto is the generic term for lenses that have a longer focal length than a standard lens. This covers a large focal length range so telephotos are often further subdivided into short telephotos (60–120mm full-frame equivalent) and long telephotos (120mm onwards).

There are two basic characteristics of a telephoto lens. The first is that the angle of view is small, restricting the amount of a scene that can be captured. The second is that a telephoto magnifies the projected image on the sensor, making distant objects appear larger in the final image. The longer the focal length of the lens, the greater the effect of these two characteristics.

UNFUSSY
Standard lenses produce unfussy and natural-looking images.

The magnifying effect of a telephoto lens makes it ideal for photographers who need to maintain a distance from their subject, but who still require their subject to be relatively large in the frame, such as wildlife photographers. On full-frame cameras, longer telephoto lenses suitable for wildlife photography can be extremely large and heavy. Because of the crop factor, many wildlife photographers use APS-C sensor cameras that can achieve a similar angle of view and magnification with a lens of much smaller focal length.

One striking visual characteristic of the telephoto lens is the apparent compression of space in an image. This results in a "stacked" feel in which elements within the image appear closer together than they actually are. This characteristic is useful when you need to suggest a unity between the different elements in the image. Telephoto lenses are also useful when you need to exclude elements from your images. Their narrow angle of view means it's far easier to crop more tightly on your subject than with a wide-angle or standard lens.

A limitation of telephoto lenses is that depth of field at each aperture is less, compared to a wide-angle or standard lens. The longer the focal length, the less depth of field is available. This often

makes it difficult, if not impossible, to achieve front-to-back sharpness. However, this apparent drawback can be used to creative effect. Telephoto lenses are ideal for a technique known as differential focusing (*see page 155*).

PROXIMITY
Telephoto lenses are ideal if you can't (or don't want to) get near to your subject.

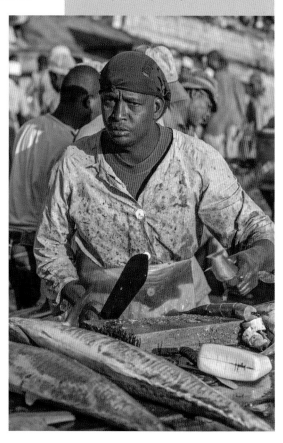

| **Understanding** Composition

Canon G10, 6.1-30.5mm lens at 30.5mm, 1/250 sec. at f/5.6, ISO 80, Aperture priority mode, evaluative metering

Compact cameras allow the use of shorter focal-length lenses to achieve the same angle of view as their larger siblings. This image was shot on a Canon G10 with the lens set to the maximum zoom of 30.5mm, roughly equivalent to a 140mm lens on a full-frame camera.

Crop factor

As mentioned earlier there is a wide range of sensor sizes employed by camera manufacturers. The largest sensor commonly used (excluding medium-format digital cameras) is the full-frame sensor, which is the same size as the 35mm film format. 35mm film cameras first made an appearance in the 1920s and became the standard for small, handheld cameras until the arrival of digital. Photographers familiar with the particular angle of view of lenses fitted to 35mm film cameras therefore tend to prefer to use full-frame cameras.

> ### Note
> *The crop factors of the different sensor sizes can be seen in the table on page 25.*

However, use a camera with a smaller sensor (such as an APS-C sensor) and the angle of view of the lens is reduced. In practical terms, a wide-angle lens will be less wide when used with an APS-C camera than when used with a full-frame camera. However, a telephoto lens will have greater apparent magnification as compensation. It's important to note, though, that the focal length of lenses doesn't change—just the angle of view. Depth of field at a particular focal length and aperture is the same regardless of what camera a lens is fitted to.

Camera and lens manufacturers often refer not to a lens' true focal length, but its "35mm equivalent." This is calculated by multiplying the focal length of a lens by a figure known as the crop factor. An APS-C sensor has a crop factor of 1.5x (or 1.6x for Canon DSLRs). Fit an 18–55mm lens onto an APS-C camera and it will have the equivalent angle of view range of a 27–82mm lens on a full-frame camera.

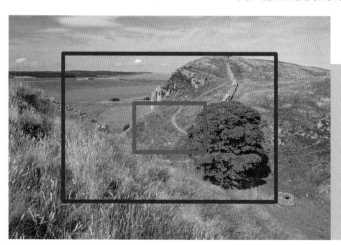

CROPPED
This image was shot with a full-frame camera and a lens set to 30mm. If the same lens were fitted to an APS-C camera the angle of view would be restricted to the red box. The blue box shows the angle of view of a 30mm lens on a camera with a 1/1.7-inch sensor.

Compact (and cell phone) cameras tend to have extremely small sensors compared to even APS-C. This means that they require extremely small focal length lenses for even a moderate wide-angle capability. A good example of this is the Canon PowerShot G16. The lens on this camera has a true focal length range of 6–30.5mm. Compared to that of a full-frame camera, the sensor has a crop factor of 4.5x (it's slightly more complicated than this as the G16 sensor has a different aspect ratio to full-frame, but this figure is close enough). Therefore the 6–30.5mm lens is roughly equivalent to a 28–140mm lens on a full-frame camera.

Depth of field is inherently greater the smaller the focal length of the lens. This means that it becomes very difficult to create images that have little or no depth of field on a compact camera (typically it's only possible when shooting macro or at maximum zoom with the largest aperture that can be set). However, it is easier to create images that have front-to-back sharpness. Your camera's sensor size is therefore a more important factor in the type of images you can easily create than you might expect.

FOCAL LENGTH
The image below left was shot with a small-sensor camera, the image below right with a full-frame camera. Both were shot with a lens equivalent to 100mm (24mm on the small-sensor camera) and using an aperture of f/4.5. The image shot with the small-sensor camera has greater depth of field due to the fact that the focal length was shorter, even though the angle of view was the same.

Perspective

In photography the term perspective is used to describe the spatial relationship—the distance and change in relative size—of the various elements in an image. A common misconception is that it's the focal length of the lens used that changes perspective. What changes perspective is the camera's position relative to the subject or scene.

The image on the opposite page was shot with a 28mm lens (top) and a 100mm lens (bottom). Although the shield at the center of the image is the same size, the two images are very different. In the 28mm shot the shield is more distorted, and in the 100mm shot the shield looks flatter and more natural. The

difference between the two shots (apart from the change in focal length) is that I was much closer to the shield when shooting using 28mm than when using the 100mm. If I'd shot the shield with the 28mm lens from the same position as the 100mm, and then cropped the image, the images would have been virtually identical (apart from a difference in depth of field). This is what I've done to the bust on this page: both images were shot from an identical position with a 28mm and 100mm lens. This time I've heavily cropped the 28mm image (left) to match the 100mm image (right). The perspective is the same because the camera didn't move between the two shots.

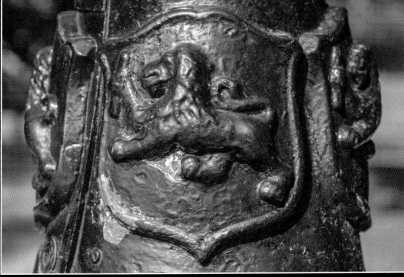

Stacked

One of the most distinctive effects of using a telephoto lens is the "stacked" appearance of elements in an image. This spatial compression is useful if you want to pull the image elements together to suggest a relationship of some kind. In this image I wanted to create an impression that, although the architecture is varied, the neighborhood is still close-knit.

Canon 1Ds Mk II,
70–200mm lens at 165mm,
1/320 sec. at f/11, ISO 100,
Aperture priority mode,
evaluative metering

Distant

Wide-angle lenses have the effect of making distant objects appear further away than would be the case if you were looking at the scene with your own eyes. This is ideal for creating a sense of space, particularly when shooting landscapes.

Canon 7D, 10–22mm
lens at 17mm, 0.3 sec. at f/13,
ISO 100, Aperture priority mode,
evaluative metering

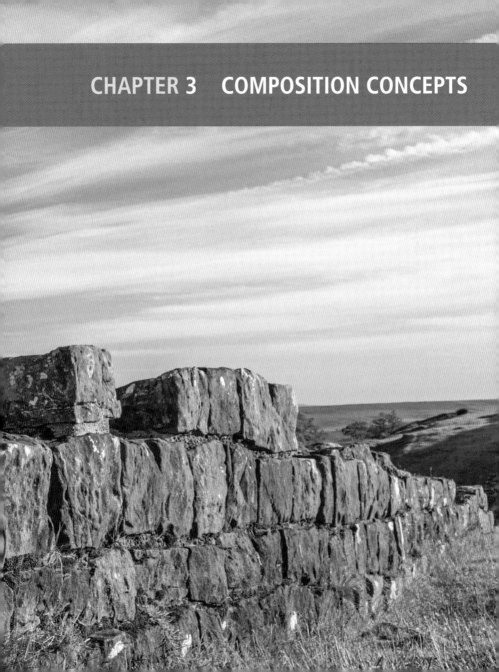

CHAPTER 3 COMPOSITION CONCEPTS

Composition concepts

In many ways there is no right or wrong answer when it comes to composition. There may be a number of different ways to shoot a scene. However, often there's one way that is preferable to others even if just marginally.

Intuition

One of the oddest aspects of composing a shot is that often something looks right in the viewfinder, but you can't articulate why. There's a lot to be said for gut feeling as opposed to mechanically applying a set of rules to composing an image. In fact, overanalyzing whether a composition has worked can be counterproductive and leave you feeling more confused than ever.

As mentioned in the previous chapter, view cameras display an upside-down image on the focusing screen. Rather bizarrely this actually helps in composition. When an image is upside down, it's easier to see past the surface details of a composition. We can view it more objectively instead, as a collection of interrelated shapes, colors, and tones—and judge whether these are in balance with each other. Although there's no room to go into detail here, viewing an image upside down enables your brain's more spatially-aware, intuitive right hemisphere to assess the image, rather than its more dominant and logical left hemisphere. Digital cameras don't show you an upside-down image before you shoot. However, it's worth turning your camera upside down (or rotating the image in-camera) after shooting, to enable you to assess the results. It may sound odd, but it's a very effective way of judging whether you got a composition right.

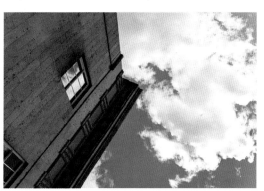

UPSIDE DOWN (Left)
Has this image worked? And, is it easier to judge whether it has worked this way up or the right way up?

BREAKING THE RULES (Opposite)
In many ways this image breaks the "rules." The subject is centrally placed, and the flower isn't completely in the frame. Do you think this matters?

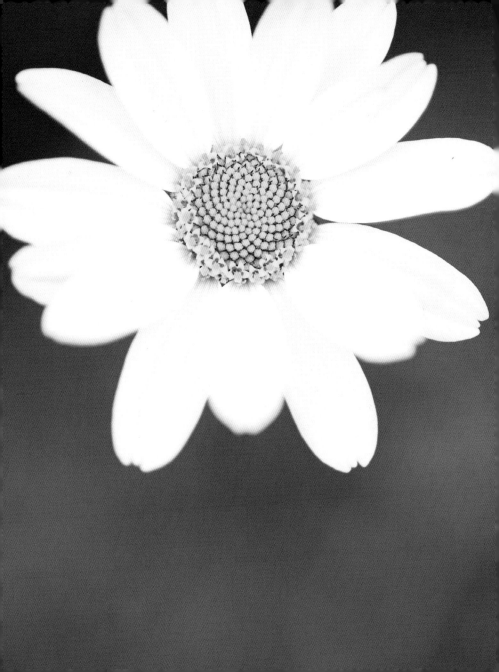

Basics

When you compose an image there are a few basic decisions you need to make. These decisions are the starting point that lead on to thinking about composition.

At its most basic, a photographic image is a four-sided rectangle (at the point of capture—you could, of course, reshape the image in postproduction). Unless you're shooting with a camera that uses a square format, the rectangle can be oriented either vertically or horizontally. There is no right or wrong orientation for a camera. How you hold your camera depends on the subject that you're shooting.

Horizontal

Arguably the subject that is most associated with the horizontal image is landscape. This is understandable, since we tend to look at views from side to side, and rarely up or down (as we'd end up looking at our feet and then into the sky). The word horizon is closely related to horizontal, strengthening the association.

Horizontal images appear more stable than vertical images (they have a broader base and an apparent lower center of gravity). This makes them less dynamic. A diagonal line that runs from corner to corner will never be as steep as a similarly-placed diagonal line in a vertical image. Vertical lines in an image will never be as long as horizontal lines, unless they leave the image space (in which case their length can only be implied).

Portraiture isn't usually associated with the horizontal format. People are taller than

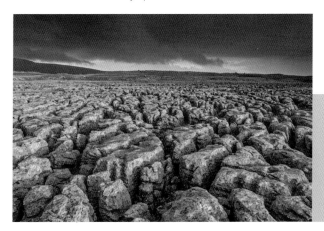

WIDTH
Shooting horizontally emphasizes a subject's breadth. In this shot there's a real sense that the pictured geographical feature continues to both the left and the right outside the picture space.

they are broad. A person shot full-length in a horizontal image will be relatively small within the picture space. However, shooting horizontally is a good way to place a person in context, to show something of the life that person leads.

Placing a vertical subject within the image space can prove problematic. Placing the subject centrally has a tendency to cut the image in two. This works if the aim is to produce a symmetrical arrangement, but can look odd when the image balance is wrong (see the relevant sections about symmetry and image balance later in this chapter). Placing a subject left or right of the center is often a better option, though thought must be given to how the larger of the two spaces is used.

Note

In photography, "landscape" and "portrait" have become synonyms for horizontal and vertical respectively. This can get confusing! For the sake of clarity, I'll use "landscape" and "portrait" to describe only the two photographic genres, and "horizontal" and "vertical" to describe the orientation of an image.

Vertical

Framing a shot vertically will emphasize height and depth over breadth. Tall buildings will appear taller and more imposing (particularly as you may have to move further back from the building when shooting

horizontally, thus making it appear smaller).

The vertical format is ideal for head-and-shoulder portrait shots, allowing the face to dominate the frame. It's a powerful statement, particularly if the subject is looking directly at the camera. However, it's arguably not subtle and leaves little room for interpretation by the person looking at the final image.

HEIGHT
Head-and-shoulder portraits work well in a vertical orientation—particularly if you don't want to include any other elements in the image apart from the subject.

Elements

The way you compose an image will depend on how many important picture elements you want to include within the image. The simplest by far is one element (or subject). This will be the most important element in the image—everything else within the image space should be there to support rather than distract from this element. The most important decision you'll need to make is where this element is placed in the image space. Placing it centrally creates a static composition that has little energy and isn't particularly interesting visually. At the other extreme, placing the element near the edge of the image is bold, but can look contrived unless there is a good reason for it being there. A "Goldilocks" placement—not too central, not too near the edge—is generally a good compromise between static

and contrived. If you have more than one important element in the image you'll need to decide what their spatial relationships with each other are. This will involve thinking about the individual visual weights of each element and the overall image balance.

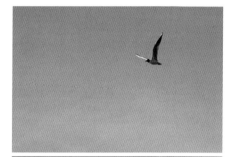

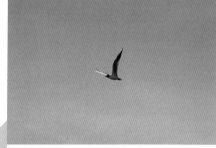

PLACEMENT
This gull is the only element in this image. The original composition (top) seemed the most natural at the time of shooting. The gull is roughly on a third (see page 56) and there is space in front of the gull in the direction of flight (see page 61). This gives a sense that the gull is moving across the image space. Moving the gull to the center of the image (middle) has weakened the energy of the original composition. There's also less sense of movement. When the gull is moved to the edge of the frame (bottom) the result feels far more cramped than the original.

Canon EOS 7D,
50mm lens,
1/400 sec.
at f/2.8, ISO
100, Aperture
priority mode,
evaluative
metering

VERTICAL

There is no right or wrong answer as to whether your camera should be held horizontally or vertically. However, numerous lines running in one direction (and relatively few in the other direction) are an indicator of the preferable camera orientation. This shot was composed vertically for this reason. A horizontal shot would have felt too contrived.

"Rules" of composition

A rule is a law or command that should be obeyed. There are a number of classic compositional "rules" that are a good starting point when learning about composition.

You'd expect that these compositional rules should be followed. In fact, it's arguably better to think of them as useful guidelines rather than rules—useful in that they work and are a good way of learning the basics of composition, but very definitely guidelines. Being creative means bending or even breaking rules. You'll find your photography will soon look forced and repetitive if you stick to these rules too slavishly.

Rule of thirds

It's probably fair to say that this rule is the most commonly described and practiced. It's a very simple rule. It requires you to mentally divide the viewfinder (or LCD) with two horizontal and two vertical lines spaced equally (dividing the image space into thirds—hence the name). In fact many digital cameras have an option for overlaying a grid on the LCD or in the viewfinder, spaced in just such a way to make it easier to apply the rule. The idea is that horizontal or vertical lines in the image space should be aligned with one (or more) of these imaginary horizontal or vertical lines. A good example of when this rule could be applied is when shooting landscapes.

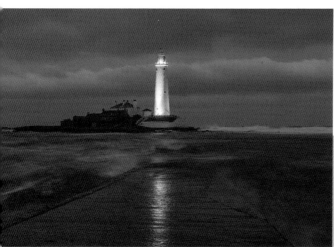

BREAKING THE RULES
This image "breaks" the rule of thirds by placing both the main subject and the horizon line centrally. Has it worked or should I have stuck to the rule of thirds on this occasion?

The horizon could be placed either on the upper horizontal line (making the foreground more dominant in the composition) or on the lower horizontal line (making the sky more dominant). The rule works in the sense that placing the main subject centrally will often produce a very static-looking image that lacks energy (though see Symmetry later in this chapter). However, the rule also seems to suggest that placing important lines or the image's subject closer to the edge of the frame should be avoided. This is as untrue an idea as that of not placing your subject in the center.

A further refinement to this rule is that the most effective place to situate the focal point or subject of an image is on one of the intersections of the horizontal and vertical lines.

PLACEMENT
The stone barn was deliberately placed on an intersection of one of the right-hand thirds. The composition wouldn't be as effective if I'd arranged it so that the barn was placed more centrally or even on an intersection on the left-hand side.

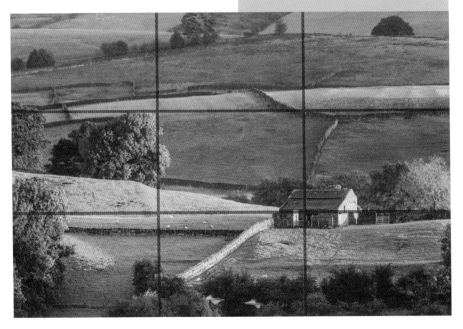

Golden ratio

This rule is also referred to as the "golden section." The rule of thirds was first put forward in the 1790s, making it a relatively recently defined compositional rule. In contrast, the golden ratio is ancient. There is evidence to suggest that the concept is over 2,400 years old. The essential idea of the golden ratio is that a line divided in two in such a way that the length of the longest part (a) when divided by the length of the shorter part (b) will produce a figure that is equal to the original line length divided by the longest part (expressed mathematically this is a + b is to a as a is to b). The figure produced is 1.618 and is referred to using the Greek letter Phi.

Photos aren't one-dimensional of course. To apply the idea to a two-dimensional image you start with a rectangular image with an aspect ratio of 1:1.618. By drawing a square at one end of the image, another rectangle within the image with the same proportions is formed. Continue to repeat this pattern within each new rectangle and you will have divided the image according to the rules of the golden ratio.

As with the rule of thirds, placing important elements in the image on the lines and intersections formed by the squares and rectangles will create a pleasing composition. Dividing an image this way is known as creating the "golden rectangle."

A further variation of the golden rectangle is known as the "golden spiral." By drawing a quarter circle in each square, a spiral is formed.

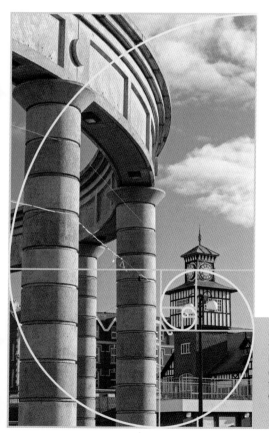

VISUALIZED
The golden rectangle and spiral are comparatively hard to visualize when composing a shot. It's easier to crop an image later using the rule. Photoshop allows you to display the golden spiral when using the Crop tool (see Chapter 6).

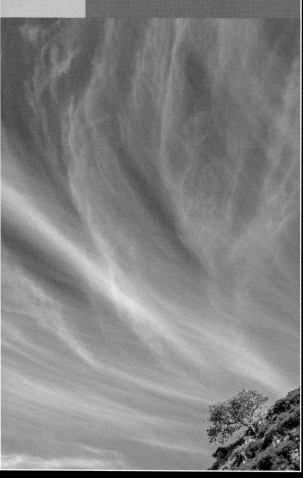

Canon EOS 7D, 17–40mm lens at 24mm, 1/80 sec. at f/7.1, ISO 100, Aperture priority mode, evaluative metering

FOR THE SAKE OF ART
Composing a photo is an art not a science. If the occasion warrants it, there's nothing wrong with bending, or even breaking, the rules. Placing the tree in the corner of this image seemed the right way to compose this shot to make the most of the swirls of cloud pointing towards it.

Golden triangle

The "golden triangle" is a way of dividing the image space up using a number of triangles of different sizes, but with exactly the same shape (the triangles being equiangular). The largest triangle is formed by dividing the image diagonally from one corner to the another. To follow the rule, place different (and visually important) elements in the image within the different triangles. The rule works particularly well if you have strong diagonals in the image that follow the line of the triangles. Placing a single element on an intersection point of the triangles arguably feels more dynamic than using an intersection point and the rule of thirds.

Rule of odds

The rule of odds is a very simple rule: an odd number of elements in a scene is aesthetically preferable to an even number. This is because with an odd number of elements there is always one that is central, framed by the others. An even number of elements is less conclusive and is more likely to produce an image that is symmetrical.

GOLDEN TRIANGLE
This image has been divided into three triangles. These keep the castle, lower illuminated building and background church spire separate.

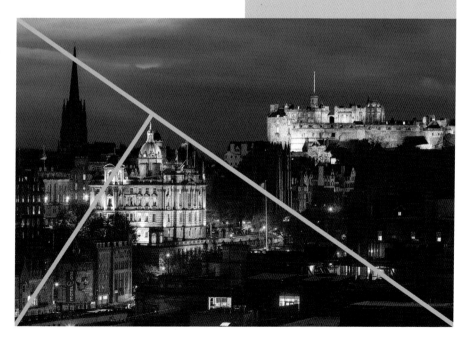

Rule of space

If your subject is a person or group of people (or even animals) you naturally tend to look at them first and then to where they are looking within the image space (unless they are looking directly at the camera, of course). The "rule of space" is based on the idea that space should be left in the image for the subject to look into. This is quite a subtle rule as you use it to imply something about the subject, for example, that they're deep in thought or that they're looking at something either inside or outside the image space (leaving it up to the imagination of the person looking at the image to work out what this is).

A variation of this rule applies to subjects that are moving. Again it's arguably preferable for there to be more space in the direction in which the subject is moving (the active space) than behind the subject (the dead space). Leaving a space in front implies intent or the sense that there's a journey to be made across the image space. That said, leaving more space behind the subject can be very effective in implying the end of a journey and to show where the subject has come from (or, in the case of a jet aircraft contrail, say, what's been left behind).

LOOKING

The puffin is looking out into empty space, implying that it may soon take off on another food-gathering flight. Try covering up the left half of the image to see how awkward the composition feels without the space.

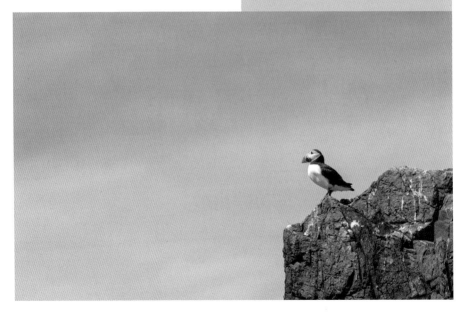

Canon EOS 7D,
10–22mm lens at 11mm,
1/500 sec. at f/11, ISO
100, Aperture priority
mode

POWER OF THREE

There's something very satisfying about the number three. It's an odd number and so can be used when shooting with the rule of odds (and is in fact the lowest number that can be used). Using three objects keeps the composition simple and avoids cluttering the image space. It's easier to arrange the objects in the frame. There are only two decisions to make: where to place the middle object relative to the outer two and where to place all three within the frame. The greater the number of objects, the more difficult these decisions become.

Other concepts

Although it's good to be aware of the compositional rules, creativity means going beyond mere formula. In doing so, it's useful to learn a few concepts that can affect the success or otherwise of a composition.

Visual weight

When we look at an image we tend to home in on the part of that image that most interests us. A subject that draws the eye in this way is said to have visual weight. There is one subject that has a tremendous visual weight: people. Place a person in an image and invariably everything else in the image is demoted to second place. This is as true of landscape images as it is of conventional portraiture. A lone figure in a landscape (as long as they are recognizable as such) will draw the eye directly to it. Interestingly, the human face has greater visual

weight than the rest of the body. This is mainly due to the fact that we are social creatures and look at people's faces to try to judge what a person is thinking and what their mood or intention is.

Certain colors have a strong visual weight. Red has a greater visual weight than blue or green and all three are heavier than yellow. Darker, more saturated colors also have more visual weight than light, less saturated colors (though pure white has a much higher visual weight than pure black).

ACTIVITY
Include a person in a landscape shot and what the person is doing will be of more interest than the landscape itself.

Other factors that affect visual weight are: shape (objects that have regular shape are "heavier" than irregularly shaped objects), texture (detailed objects or those with a complex texture are "heavier" than smoother objects), and position in the image space (visual weight increases the further an object is from the center of the image—objects right of center appear heavier than identical objects left of center, and an object in the top half of an image appears heavier than an identical object in the bottom half). Diagonal lines also have more visual weight than both horizontal and vertical lines. Finally, text and recognizable symbols are particularly visually heavy.

When composing an image you need to think about visual weight. Something that is "heavy" visually will dominate the image. If this isn't your subject you may find that your subject is ignored or is seen as less important by people viewing the resulting image.

Balance

Closely related to the concept of visual weight is the idea of balance. The idea is simple: if your image was on a pivot, would it tip because it was visually heavy on one side, or would it remain perfectly balanced? Symmetrical images are good examples of balance at work. However, by their nature, symmetrical images can look static, and create the impression that there are two separate halves to the image. Asymmetrical balance, though more difficult to achieve, is generally preferable as it looks less contrived.

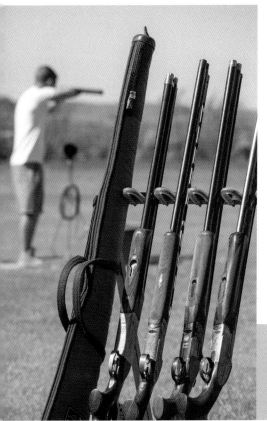

ASYMMETRICAL
I composed this shot so that the visually heavy figure was smaller relative to the gun rack in the frame. This has helped to make the image feel balanced even though it's an asymmetrical composition.

Nikon 70D,
70–210mm lens at
105mm, 1/400 sec.
at f/5.6, ISO 200,
Aperture priority
mode

BALANCED

Images that are symmetrically balanced can
look static. This image is perfectly balanced with
the centerline of the building running exactly
down the center of the image. However, it's
more of a record shot, rather than one that's
visually interesting.

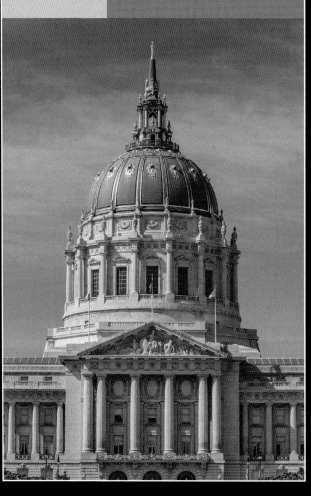

Lines

Including lines in an image is a very powerful way of directing a viewer's gaze through the image space. The lines don't have to physically exist—they can be implied through the way elements in the image are aligned. There are three basic angles of line: horizontal, vertical, and diagonal. Of the three, the diagonal line is the most dynamic and has the greatest amount of energy.

A leading line is one that leads the eye to the main subject of an image. Good examples of elements that can be used as leading lines are paths, roads, plow furrows in a field, and geological strata. Typically, leading lines begin in the foreground of an image and lead the eye

upwards. But there is no reason to stick with this formula rigidly. If you can find them, leading lines starting at the top of the image space and leading downwards can be just as effective.

The one danger with lines is that if used carelessly they can lead the eye out of the image space. It pays to be aware of any potential lines in an image that may do this accidentally and keep them out of the composition.

FORCE
Lines can add energy to an image. Here the lines of the cloud help to convey motion, reinforcing the struggle of the figure. A clear blue sky would not have been as effective.

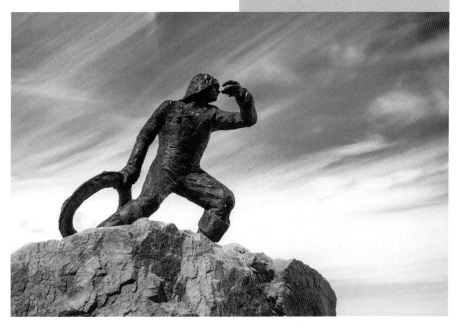

Nikon D600, 50mm lens, 1/160 sec. at f/14, ISO 100, Aperture priority mode, evaluative metering

EYE LINES

Lines are a very powerful way to direct a person's gaze through an image space. To see the effect, cover the tramlines in the foreground. Does the image (in this "cropped" form) work as well, or are the tramlines a vital component of the composition?

Curves

As with lines, curves in an image can be either physically real or they can be implied. "Real" curves include rivers, railroad tracks, even the edge of the sea as the tide ebbs and flows. There are two basic shapes to a curve: the "C" shape and the "S" shape. The shape of the curve approximately matches the shape of the letter it's named after. The C curve is the simpler of the two shapes, the S curve more sinuous and complex. The S curve is typically longer than a C curve and so it takes the eye more time to follow its line. The S curve's more meandering quality is arguably more restful and hypnotic than a C curve.

Using a curve in a composition is a powerful way to guide the eye through the image space—it's almost impossible to look at a curve and not follow its length. This means that it's important to consider what happens when the eye reaches the end of the curve. One solution is to place the focal point of the picture at the end of the curve, so that the eye has a natural destination place in the image. What should be avoided is placing the subject so that it has no connection to the curve. Doing this will produce a slightly unsettling effect: the eye will need to move away from the curve to look for the subject (if at all—it may be that the subject goes unnoticed or is relegated to just a supporting role in the composition).

However, you don't need to have a separate subject in the image. The curve itself could be the subject. A good example of this is a river winding through a landscape. This will have an emotional resonance of its own. Anyone looking at the image will just enjoy the visual journey.

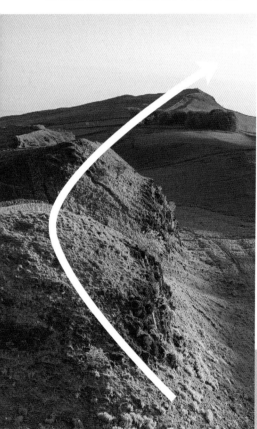

IMPLIED
Curves can be implied. In this image it's the areas of light and shade that suggest a curved path through the image.

Nikon D600, 35mm
lens, 1/15 sec.
at f/16, ISO 100,
Aperture priority
mode, evaluative
metering

S CURVES

A gently meandering S curve helps the
eye to slowly wander through an image.
Curves (S curves in particular) feel more
natural than straight lines with good
reason. Perfectly straight lines are very
rare in nature and only tend to be found in
artificial structures.

Framing

Framing is the technique of using an element in a scene to partially or even fully surround the main subject. There are several reasons to do this. The first is that it will help to direct the eye towards the main subject, provided that the framing element isn't too intrusive or distracting. It will also help to make an image more three-dimensional by adding another depth-cue to the composition. Framing elements can help hide or reduce the impact of other, unwanted elements in a scene.

By carefully choosing your frame you can give your subject more context. A framing element that is related to the main subject (such as an open doorway framing a room) will help to tell the story of the image very economically. Framing elements that don't match the main subject will add an air of mystery. By juxtaposing two disparate elements there is an immediate tension to the image, which the viewer of the image will need to resolve.

Framing elements don't necessarily need to be sharp. By throwing them out of focus they will be less likely to distract from the subject, and as a bonus will also increase the apparent depth of the image. If the framing element is in shadow, care must be taken that this does not influence the exposure to the detriment of the subject, particularly if the subject is brightly lit. Framing elements that are silhouetted are very effective and are less likely to be distracting.

SIZE
The subject can be relatively small compared to the framing element as long as it has greater visual weight.

Nikon D600, 100mm lens,
1/160 sec. at f/11, ISO 100,
Aperture priority mode,
evaluative metering

HIDING

Framing can be done for many reasons. In this instance I wanted to avoid including too much of the pale blue sky, which added nothing to the shot. Care was taken to ensure that the overhanging branches of the trees didn't overlap or obscure the most important parts of the castle.

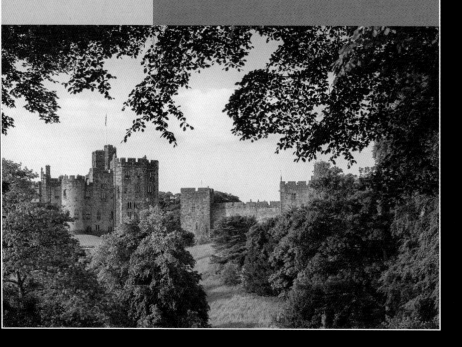

Nikon D600, 28–80mm lens at 30mm, 0.4 sec. at f/10, ISO 100, Aperture priority mode, evaluative metering

REFLECTIVE
Symmetrical compositions by their very nature feel balanced. This can lead to calm, but relatively uninteresting images. One way to add tension to a symmetrical image is to include an element that breaks the symmetry. In this image the inclusion of the boats adds visual interest to the otherwise balanced composition.

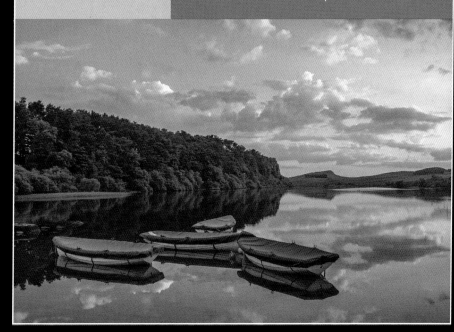

Symmetry

A simple definition of a symmetrical composition is one in which one half of the image is a mirror or is similar in some way to the other half, so that if you were to fold the image in half, the two halves would match). Reflections in still water are a good example of symmetry because the water is an almost exact mirror of the subject it's reflecting. Other types of symmetry are more complex. As well as "mirror" symmetry there is "radial" symmetry, in which the symmetry radiates out from a point. A good example of this type of symmetry is the petals of a flower.

Symmetrical compositions are inherently restful. There is little tension involved and no visual puzzle to be "solved." However, more negatively, symmetrical compositions can seem dull and lacking in dynamism. Another danger of repeatedly using symmetrical compositions is that they can begin to look contrived.

A more subtle type of symmetry is one that involves a resemblance of shape or color in the two halves of an image. Although this may not produce a perfect mirror, this type of symmetry requires more decoding by a viewer and is thus more likely to retain interest.

One powerful way to use symmetries is to deliberately add an element that breaks into the symmetry somehow. This is a good way to draw the eye to this element as it will add a note of dissonance to the image. The key is to decide where to place this element. Placing it on the "fold line" will be less powerful than placing it above or below.

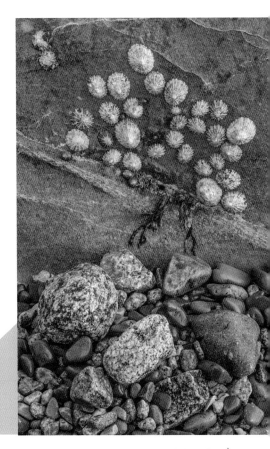

SUBTLE
A more subtle symmetry than a reflection is when elements that resemble each other in shape or color are used. In composing this shot I was struck by how the shape formed by the lower pebbles was roughly the same as the cluster of limpets.

Repetition

Repeating patterns are found in both the natural and the man-made world. Repetition within an image is inherently pleasing to the eye and soothing. Humans have a particular fondness for repetition in images, especially if there's a strong suggestion that the pattern continues outside the boundaries of the image space. To achieve this, the repeating pattern will need to extend right to the edge of the image, or the space around the edge of the image will need to be similar in size to the spaces in the repeating pattern.

The one problem with repeating patterns is that they don't hold the attention for long. To add a dynamic quality to a repetitive pattern, add an element that breaks the pattern somehow. This element will immediately become the focal point of the image. The eye will quickly scan across the repetitive areas of the image and stop when it comes to the break in the pattern.

Long focal length lenses are ideal for cropping in on patterns. However, depth of field can be an issue, unless the pattern is on a flat plane parallel to the camera. If the pattern is three-dimensional you may need to use a relatively small aperture to ensure that the entire pattern is in focus. Any areas that are out of focus will break the pattern.

FOCAL POINT
Anything that breaks a pattern will become the focal point of the image. Where did you look first?

Canon EOS 7D, 70–200mm lens at 200mm, 26 minutes at f/16, ISO 100, Bulb mode

LUNAR TICS

This image relies on the repetition of the moon across a single image for its effect. It was achieved by using a 26-minute exposure in Bulb mode, keeping the lens covered with a black cloth. Every three minutes the black cloth was lifted for a second to expose the moon. As the moon climbed in the sky it was recorded in a different place in the image. The key was allowing enough time to elapse between each lifting of the cloth so that the moons didn't overlap each other.

Canon EOS 5D,
50mm lens, 1/125
sec. at f/7.1, ISO
200, Aperture
priority mode

ABOVE
By gaining sufficient height (such as in
a hot-air balloon to shoot this image)
you immediately make your image
more abstract. Fine detail is lost, to
be replaced by a greater emphasis on
shape, line and color.

Viewpoint

Simply put, the viewpoint is the view you see through your camera's lens when you compose a shot. Your viewpoint is affected by the distance and angle between you and your subject. The two are intertwined—the further back you are from your subject, the shallower the angle. Close to, the angle will be steeper, particularly if the subject is smaller or larger than you.

It's probably fair to say that most photos are shot at the photographer's eye level. And why not? It's a viewpoint which we're used to. However, it's not particularly creative. Digital cameras, especially those with fold-out LCDs have made it far easier to compose below or above eye level.

The height that you shoot from should be a height that produces the most sympathetic or interesting view of your subject. Looking down to shoot something shorter than you (a child or animal, for instance) or looking up to shoot something taller than you, will produce an odd and unflattering perspective of your subject. This will be exacerbated by the use of a wide-angle lens, particularly if you're virtually

on top of your subject. Getting down or up to your subject's level will produce far more natural-looking and intimate images. That's not to say that being higher than your subject is necessarily a bad thing. Looking down from a greater height will produce a more emotionally remote, abstracted image of your subject.

HEIGHT
Shoot at the same level as your subject for a more flattering result.

Abstraction

An image that does not represent "reality" in a literal way is said to be abstract. Rather than relying on detail, abstract images tend to be more about shape, texture, color, or all three. Abstract images are harder to "read" than a more literal representation and create more of a puzzle for the viewer of the image to work out, potentially holding the viewer's interest for longer, a trait they share with ambiguous images—see page 87.

Abstract images can be created in a number of ways. Longer lenses are useful to crop in tightly on a subject, reducing the amount of visual information that would help make the image more recognizable. Using a large aperture to minimize depth of field or even deliberately defocusing, so that the scene is reduced to patches of color, are also very effective ways of creating an abstract image.

There are two approaches you can take when composing an abstract image. The first is to apply the compositional rules and concepts previously described to align elements within the image space—even to have a primary element towards which the eye is directed. This creates a more formal image, albeit one that is still relatively hard to read. The second approach is not to use any rules of composition at all, and to produce a more free-form image with no particular point of interest. This means that the eye of the viewer is freer to wander around the image space. To create visual interest it's therefore important to be bold with shape, texture, or color.

COLOR
This abstract image is purely about color—color created by light from an intense sunset reflecting on an area of wet sand.

Canon EOS 5D,
17–40mm lens at
40mm, 1/6 sec.
at f/14, ISO 100,
Aperture priority
mode, evaluative
metering

EXCLUSION
It's generally more difficult to shoot
abstract images with a wide-angle lens.
Abstracts rely on the fact that there is
little more information in the image than
is strictly necessary. For this image I relied
on the longer end of a wide-angle zoom
to exclude anything other than the curves
of the rock that most interested me.

The subject

The subject of a picture doesn't necessarily have to be the largest element in the image. However, the subject should still be the most important element and not be overshadowed by other elements.

Size of subject

There is no right or wrong answer to the question of how big your subject should be within the image. Filling the frame with your subject gives a picture impact. However, this doesn't allow the viewer of your image much leeway in how the image can be interpreted.

Nor should your subject be so small in the frame that it's no longer possible to identify the subject, or that the subject is visually dominated by other elements in the image. Generally, subjects that have a heavy visual weight (such as a person) can be smaller in an image than a subject with less visual weight and yet still be recognizably the subject of the image.

The lens you use and your position relative to your subject will be a big factor in how large the subject will be within the image. The use of a wide-angle lens will reduce the size of your subject within the image unless your subject is close to the camera—though being too close will produce an unnatural and unflattering perspective, which is particularly noticeable when shooting portraits.

SIZE
Despite being relatively small in the image space, this little statuette is clearly the subject. This is partially positioning—there is a flow of line from the top left corner to the figure—but also the fact that the figure is visually heavy compared with the other elements of the scene.

Filling the frame

By filling the frame with your subject you exclude everything but your subject. This immediately creates striking images with impact. However, it's an approach that needs to be used with care. Because your subject dominates the frame, any flaws in your subject will be immediately apparent. If your subject is a person they have to be comfortable with this possibility.

Successfully filling the frame means doing precisely that. When composing the shot it's important to check around all four edges of the frame. If you're not filling the frame, so that your subject stretches to the four corners, you need to either get closer or zoom in more (the latter is preferable for live subjects as this is less intimidating than the former).

Where you focus is also important. Getting in close or using longer lenses may restrict your available depth of field. You will need to decide which part of your subject needs to be critically sharp and compromise on other areas if they fall outside the zone of depth of field.

FOCUS
Where you focus is critically important when filling the frame with your subject. In this shot I focused on the front float and didn't worry too much about the ones behind it being slightly soft and out of focus.

Canon EOS 5D,
100mm lens,
1/200 sec. at
f/7.1, ISO 320,
Aperture priority
mode, evaluative
metering

EXCLUSION
Filling the frame is easier with a longer
focal length lens than a wide-angle.
Using a longer lens also means that you
can stand back from your subject, which
makes the perspective more natural.

Context

Placing your subject in context is the exact opposite of filling the frame with the subject. The subject is far smaller in the image and is shown in its environment. This helps to tell the story of your subject. A simple head-and-shoulders shot of a person tells you nothing about them other than what they look like. Showing the same person hard at work shows you what they do for a living, their work environment, and even potentially whom they

work with. However, there is a fine balance that has to be struck when showing a subject in context. You shouldn't allow the environment to become more important than the subject. This is relatively easy to avoid with people as they have a high visual weight (if there is more than one person in an image, your subject should be the larger in the frame relative to the others). However, if your subject is inanimate you will need to think carefully about its relative size and positioning within the image space.

ENVIRONMENT
Your subject shouldn't be lost in an image when you show context. In this image the lighthouse is still visually dominant even though it's relatively small in the frame.

Canon EOS 7D, 17–40mm lens at 24mm, 3.2 sec. at f/22, ISO 100, Aperture priority mode, evaluative metering

THE BIGGER PICTURE
By using a wide-angle lens for this image I've added context. The scale of the waterfall is easier to discern as is the environment in which it sits.

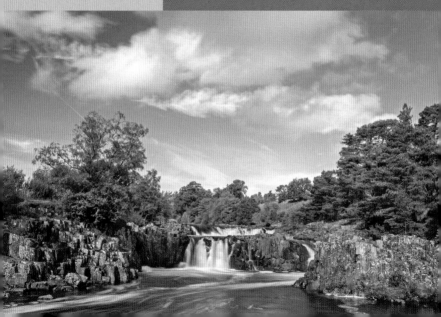

Simplification

The world is a complex place. All photographs are a simplification of this complexity. However, it's possible to push this simplification further to create minimalist images that have just the bare amount of visual information in them. The essence of simplicity is reducing visual clutter. This can be achieved in a number of ways. Using a long focal length lens helps in two respects. The narrow angle of view immediately forces a more constrained, simplified view of a scene. Using a large aperture will also restrict depth of field, helping to simplify the image further.

The way you expose an image will also determine how simple that image is. As already mentioned a shallow depth of field simplifies images. If you have movement in a scene, using a long shutter speed will soften and blur the movement. However, it's difficult to use a long shutter speed and large aperture to minimize depth of field and blur movement. You could wait until the light levels are naturally low, such as after sunset. Alternatively you could use extremely dense neutral density (ND) filters to artificially restrict the amount of light reaching the sensor, allowing the use of a long shutter speed and large aperture.

In the natural world snow and mist help to simplify landscapes. Snow obliterates texture and color. Under the right conditions, snow-covered landscapes can look very minimalist and monochromatic. Mist reduces color as well as contrast. When mist is particularly heavy it can restrict visibility to the point where only objects close to the camera can be discerned clearly.

SHAPES
The use of a two-second shutter speed on this coastal scene has blurred the movement of the sea. Shooting on a heavily overcast day has simplified the composition further.

Nikon D600, 100mm macro lens, 1/50 sec. at f/16, ISO 100, Aperture priority mode, evaluative metering, off-camera flash

WHITE

The very simplest images are those that consist of just the subject against a plain background. In this shot I used white. I did try a black background initially, but the darker details of the fly weren't as clearly defined (particularly the legs and the delicate hairs). Fortunately, the fly didn't mind all this experimentation and flew off afterwards, unperturbed by the attention...

Ambiguity

Typically it only takes a second or two for the intent of a photographic image to be understood. Ambiguous images are those that are initially difficult to read. They may take a few minutes or more of looking before the subject or aim of the image is apparent. This may be due to the sense of scale not being immediately discernible or because of the way the image has been framed or focused. Ambiguous images require the viewer of the image to work harder in puzzling it out. This may sound an odd thing to aim for, but ambiguous images arguably engage more because they are better at stimulating the viewer's imagination.

It's generally more difficult to create ambiguous images with wide-angle lenses. They often convey too much information. Longer lenses make it easier to isolate a specific area of a scene and exclude those elements that would provide too much of clue to the image content.

REFLECTIONS
The reflections in this display case make it pleasingly difficult to work out the viewpoint from which the image was created.

Humor

Humor is very subjective, and individuals within a society differ in their appreciation of humor—what one person finds funny may leave another completely cold.

There are also often substantial differences in humor between cultures. At a very basic level, humor can be described as the juxtaposition of two contrasting concepts. It's the attempt at internally resolving the two concepts that provokes laughter.

Photographically, there are two types of images that provoke laughter (or a wry smile). There are images that are simple records of something that was already funny (a humorous sign or a person pulling a face). The second, and more subtle type, uses two contrasting elements that are juxtaposed in an unusual or unexpected way. This second type is similar to the sight gag beloved of cartoonists. It's the more difficult to spot, but is arguably more rewarding and original than the first type. (It's been created by you, and may never have been spotted by anyone else.) Simplicity is the key once more. A humorous image should only contain the two contrasting elements and ruthlessly exclude anything that doesn't add to the joke.

FACES
Unusual expressions on people's faces can usually provoke a smile. The expression of dismay on this girl's face as her brother muscled in on a photograph always makes me smile.

Canon EOS 7D,
50mm lens, 2 sec.
at f/5.6, ISO 100,
Aperture priority
mode, evaluative
metering

HUMOROUS?

The one problem with creating
humorous images is that humor is
personal. I find the expression on the
face of this stuffed badger amusing, but
that doesn't mean that you will.

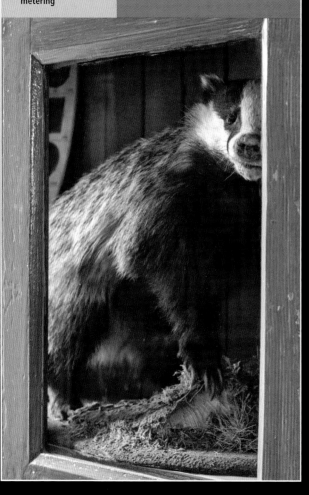

Decisive moment

Some images could conceivably be shot at any moment in time—others are very much of the moment, a split second earlier or later and the image may not have been as effective.

Split-second timing

There are some images that can be set up and shot without thinking about timing. A still-life composition could be shot at any point once the camera has been set up. However, add movement into the equation and there arise photographic compositions that may require split-second timing: when the various elements of the image come together in front of the camera to form an interesting and unique moment in time. Once that split second has passed so has the photographic opportunity. This concept is known as the "decisive moment."

The key to making the most of the decisive moment is anticipation. This requires an understanding of what is happening around you and how events will progress to the point when the photographic opportunity is at its optimum. A good example of this is a sporting event. Knowing the rules and how the sport's action ebbs and flows will allow you to more accurately predict when something interesting is about happen.

The genre most closely associated with the decisive moment is street photography. Successful street photography requires an understanding of people, their behavior, and how they react to events. Learning to read body language is therefore a good skill to acquire to anticipate events on the street.

> ### Note
> The photographer who coined the phrase "decisive moment" was Henri Cartier-Bresson, who was active from the 1930s to the mid-1970s.

FLEETING
There are photographic opportunities that last for a brief second before they're gone forever.

Equipment

Any camera can be used to shoot decisive moments. However, some are better suited than others. Split-second timing requires a camera that's ready when you are. Cameras that suffer from tardy AF or shutter lag may cause you to miss an opportunity.

The classic approach to street photography was to use a camera fitted with a prime lens—either 35mm or 50mm on a full-frame camera. This was partly because, until comparatively recently, zooms could not match primes for image quality—the gap is far narrower now. It was also because the street photographer learned to "see" images at a particular focal length. The image would therefore be composed before the camera was even brought to the photographer's face, saving precious time and ensuring that the photographic opportunity wasn't missed. Quite often the lens would be prefocused too. Again the photographer learned to judge where to stand to ensure a sharp image. Using a mid-range aperture such as f/8 also meant that depth of field was sufficiently large so that focusing errors were less important. It's a technique well worth experimenting with, particularly if you don't have the fastest camera in the world.

DISCRETION
This was shot with a Holga "toy" camera, a film camera with a 50mm (equivalent) lens. Although not an ideal street camera it has the benefit of being unobtrusive, perfect for those moments when you don't want to draw attention to yourself.

Visual weight

People are visually "heavy." A person in an image—even if relatively small—will be the main focus of attention. Cover up the figure in this image to see the difference it makes to how you perceive it.

Nikon D600, 28–80mm lens at 35mm, 1/320 sec. at f/8, ISO 100, Aperture priority mode, evaluative metering

Ambiguity

Even though the figure on the right is out of focus, it's still possible to work out what he's doing (and the tabard of the figure on the left is a big clue). You don't necessarily have to convey your subjects in a straightforward way for the concept of the image to become apparent.

Nikon D600, 70–300mm lens at 260mm, 1/500 sec. at f/5.6, ISO 100, Aperture priority mode, evaluative metering

CHAPTER 4 LIGHT AND COLOR

Light and color

Without light you couldn't make a photograph. However, light has many different qualities that need to be understood and appreciated. The way light is reflected or absorbed by objects also determines how color is perceived or recorded.

Photography

It's right there in the name: photography, or "writing with light" from the Greek *photos* (light) and *graphos* (writing). When you click the shutter button you craft an image using light. Exposure is the technique of controlling

COLOR
Blue and red are at polar opposites in terms of emotional impact on an image. Understanding why and how this can be used is all part of the decision-making process when composing a shot.

how much light is used to make an image. However, there's more to using light than measuring it like an ingredient in a recipe, although this is an important aspect of photography. The qualities of light, such as how hard or soft the light is, should be an inspiration too. The different qualities and how they will affect the images you create are described in this chapter. Light also determines color. Remarkably, colors have emotional impact. The way you use color in your images will therefore determine how they are perceived, and this consideration should be an important part of the previsualization process.

WARMTH *(Opposite)*
The warmer colors of the far room look far more inviting than the slightly cooler colors of the foreground.

What is light?

It's a question that doesn't get asked enough by photographers. An understanding of how light "works" will help you plan how your photos are lit and exposed.

Waves

The electromagnetic spectrum is the range of wavelength frequencies of electromagnetic radiation. It stretches from gamma radiation at one end to radio waves at the other. Visible light is a small fraction of the electromagnetic spectrum, starting at a wavelength of approximately 700 nanometers (nm) and ending at approximately 400nm. When the wavelengths of light are separated through a prism they form the colors of the rainbow. Red wavelengths of light are longest (at 700nm) followed by orange, yellow, green, blue, indigo, and violet (at 390nm). The longer the wavelength of sunlight, the less it is scattered by particles in the atmosphere. This has a bearing on the color bias of light during the day (see page 108).

Texture

The texture of an object determines the nature and strength of reflected light. Smooth, high-gloss surfaces create a specular reflection in which the angle of incidence (the angle at which the light rays hit the surface) is equal to the angle of reflection (the angle at which the light rays are reflected away from the surface). A smooth, high-gloss surface produces a reflected image that appears to be reversed left to right, an effect referred to as lateral inversion. The more smooth and glossy the surface, the more light is reflected and the brighter the reflection. The most common artificial surface that exhibits this behavior is the mirror. Gloss surfaces in nature rarely exhibit a mirror's level of light reflection.

RAINBOWS
Rain acts as a natural prism, separating the wavelengths of sunlight into its constituent colors.

Metals generally need to be processed by polishing to create specular reflections. Water, even when perfectly still, is far less reflective than a mirror (the surface of water is never entirely smooth and so some light is scattered randomly). Rougher, more matte surfaces scatter reflected light rays in random directions. This is known as diffuse reflection and does not produce an image. Most natural objects produce diffuse reflections.

Not all the wavelengths of light that strike a matte surface are necessarily reflected. We see the color of an object by the way the surface reflects or absorbs different wavelengths of light. A red object will absorb all the wavelengths of light except those that correspond to red. These red wavelengths are reflected back towards the eye and our brain interprets the object as being red—a pure white object reflects all the wavelengths of visible light equally, a black object absorbs all the wavelengths equally. If the surface of an object has both a specular and diffuse reflective quality only the diffuse reflection causes color to be perceived. The specular reflection is seen as a pure white highlight.

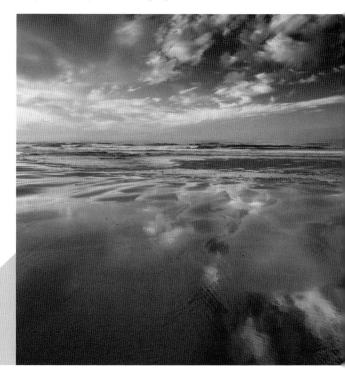

WATER
We instinctively know that reflections in water are darker than the subject being reflected. Exposing an image so that the reflections are lighter looks unnatural.

Qualities of light

There's a saying among photographers that there's no bad light, just bad photography. Light has many different qualities. Matching the right light to your subject is important.

The easiest of light's many qualities to understand is its direction relative to the camera. Light can be cast from behind the camera onto the subject, fall onto the subject from the side or emanate from behind the subject towards the camera. The direction in which light falls relative to the camera will determine where highlights and shadows are cast, how the shape of your subject is perceived, and the level of contrast. Another important quality of light is its hardness or softness. This is also the determinant of contrast, as well as the depth and sharpness of shadows.

Frontal lighting

Frontal lighting is light that is cast from behind, just above, or slightly to the side of the camera (or actually from the camera itself when direct flash is used). Front lighting is relatively easy to use. It produces low-contrast illumination (shadows are usually invisible as they are cast behind the subject), which is easy to correctly expose. However, frontal lighting lacks drama. It's a good light for simple portraits, particularly with older people, as skin texture such as lines or blemishes will be less apparent. It's this flattening effect that makes frontal lighting less aesthetically pleasing for subjects that require texture to be emphasized, or when shadow detail is required to define shape and form.

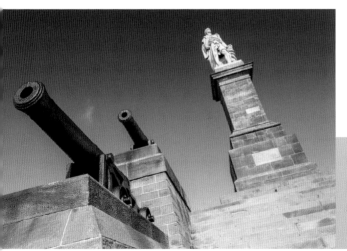

FRONTAL LIGHTING
This was a first attempt at creating an image of this statue. With the sun behind the camera the texture on the stonework was flattened and there were few shadows to define shape.

Side lighting

Also known as oblique light, side lighting is light that is cast at 90° to the camera. Unlike frontal lighting, side lighting is ideal for showing texture and defining a subject's shape. It's also arguably a more atmospheric lighting direction than frontal lighting. The one problem with side lighting is that contrast can be high, particularly when a hard light source is used (*see page 105*). If you're working with small subjects, this can be rectified by the use of reflectors or supplementary lighting.

Backlighting

Backlighting occurs when the light is behind the subject and pointing towards the camera. This means that contrast is high, with the background generally brighter than the unlit subject. Metering for the background will render your subject as a silhouette (*see page 120*). One way to avoid this is to use extra lighting, such as flash, so that the exposure for the subject and background match. Another problem with backlighting is that the risk of flare is increased. Flare is non-image forming light that bounces around the glass elements of a lens before reaching the sensor. Flare caused by light shining into the lens this way can't be stopped by using a lens hood. Keeping the light hidden by your subject is a good solution to this problem. Happily, if you're shooting portraits, it also helps to create an effect known as rim lighting, in which the outline of the subject's hair glows in an aesthetically pleasing way.

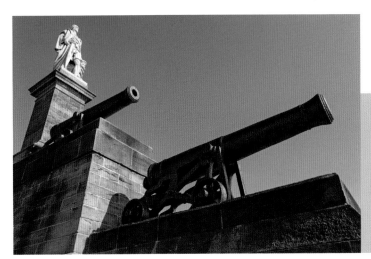

SIDE LIGHTING
By moving around to the side of the statue, I've turned frontal lighting into side lighting. The statue and the stone base now appear more three-dimensional.

Nikon D600,
70–300mm lens
at 120mm, 1/3200
sec. at f/5, ISO 200,
Aperture priority
mode, evaluative
metering

BACKLIGHTING
Shooting into the light means that contrast is high.
The side of the subject facing the camera will,
without supplementary lighting, tend to become
silhouetted. Another effect of backlighting is that
color can become less vivid and the image more
monochromatic as a result.

Contrast

Contrast can have a number of meanings photographically. It can refer to visual contrast between disparate subjects (in color, texture, or some other factor). It can also refer to the degree of separation between the darkest and lightest parts of the image—the meaning described here.

Contrast is determined by the hardness or softness of the light (*see pages 105–106*). A low-contrast image has very little difference in terms of tone between the brightest and the darkest part of the image. Low-contrast conditions can make images look flat and lacking in impact. However, low contrast isn't always undesirable and in some situations can

be used to good effect. Shooting on a misty day will produce low-contrast images, but the effect can be intriguing and mysterious.

High-contrast images have far greater separation between the brightest and darkest areas. The highest contrast is achieved when the only tones in an image are black and white. High-contrast images can be stark, but they can also be very graphic and punchy.

Of the two, it's easier to shoot in low-contrast light. High-contrast conditions can challenge the dynamic range of a camera (*see page 104*). It's also easier to add contrast to an image later than to remove it. See Chapter 6 for more details.

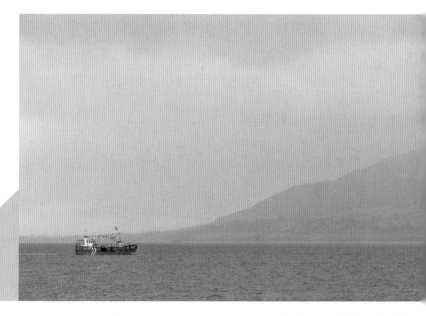

DIFFUSE
The diffuse light of an overcast or misty day is low in contrast.

Dynamic range

Dynamic range describes the maximum and minimum range of light levels that a camera can successfully record without detail being lost (either in the shadows or in the highlights). High-contrast scenes, particularly those that vary widely in levels of reflectivity, are the biggest test of a camera's dynamic range.

Cameras vary in their capabilities. Cameras with larger sensors can typically record a greater range of brightness levels than those with smaller sensors. However, no camera can currently match the dynamic range of the human eye. Assessing whether the range of light levels is outside the capabilities of a camera is therefore something that has to be learned. Fortunately, with practice that gets easier. Scenes that exceed the dynamic range

of a camera require either a compromise in how the image is exposed or for the contrast to be lowered (by the use of reflectors or supplementary lighting). Exposure compromise means setting the exposure so that detail is either retained in the highlights and lost in the shadows or vice versa. Generally, it's better to lose detail in the shadows. We expect shadows to be dark so it's less surprising to see than when highlight details are lost (often referred to as "blown" highlights).

HIGHLIGHTS AND SHADOW
This is the sort of scene that tests a camera's dynamic range. In the shot on the left, the exposure was biased towards the unlit leaves framing the church. In the shot on the right, spot metering was used to set the correct exposure for the church. Although this means that the leaves are far darker, this is a more acceptable exposure.

Hardness

Hard lighting is created by point light sources. A point light is one that is smaller than the object it is illuminating. Oddly enough, the sun is a point light source. Even though it's massive (over a million Earths would fit into the same space as the sun), the sun is also sufficiently far away to be relatively small in apparent size. Another good example of a point light source is an ordinary domestic light bulb.

Hard lighting produces shadows with very sharply defined edges and, if the subject is glossy, bright specular highlights. The shadows also tend to be deep, and contrast is high between the lit and unlit areas of an object. The closer the point light source to the object, the more sharply defined the shadows. One way to soften a hard light source is to move it away from the object it's illuminating. Another way is to add a diffusing medium between the light and the object. Flash is another example of a point light source. Flash is often softened either by using a reflector to bounce the light towards the subject or by using a diffuser such as a softbox.

However, hard light doesn't necessarily need to be softened. There are some subjects that benefit from the sculptural effects of hard light. Portraits of men arguably benefit from the use of hard light, as does architecture with a strongly-defined form. Hard light (when used as side lighting) is also good for helping to show texture and shape.

SUNLIGHT
The light from the sun high in a cloudless sky can be hard. This is less than ideal for most subjects, but can be good for architecture with bold form.

Softness

Soft light is created when the light is relatively larger than the subject it's illuminating. Soft light is low in contrast as it "wraps" around the subject. This means that shadows are lighter and more diffuse with softer edges. Highlights are also not as bright and are more attenuated.

The light from the sun is softened on overcast days or when there is mist. This is because the light is more diffused and so appears to emanate from a greater area (thus making the light source larger). When the sun is on the horizon, its light is often softened too, due to particles in the atmosphere scattering the light more. Shade is another example of natural soft lighting. Objects in shade are lit purely by ambient light from above, rather than by a direct light source.

Point light sources such as incandescent bulbs produce hard lighting. Domestically, we soften this light through the use of shades or paper globes (essentially the same as fitting a flash to a softbox, as described previously).

Soft light suits certain subjects, particularly delicate subjects such as flowers. However, soft light can often flatten texture, making subjects appear slightly flat.

OVERCAST
The flat, almost shadowless, light of an overcast day.

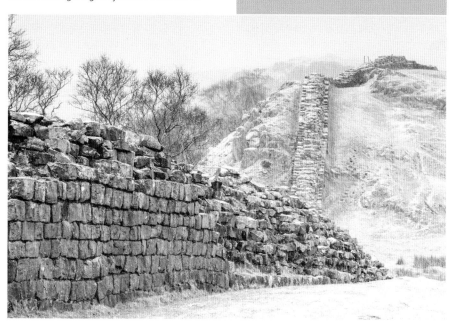

Canon EOS 1Ds Mk II, 17–40mm
lens at 19mm, 1.6 sec. at f/14,
ISO 100, Aperture priority
mode, evaluative metering

TEXTURE
Hard side lighting is an excellent lighting scheme for emphasizing
texture. This shot would have been less effective if the light had been
softer and the shadows more open.

Color temperature

A bias of one wavelength of light over the others will alter the color of the light. This is known as a difference in the color temperature of the light.

Color bias

The term color temperature refers to the way in which the color bias of light is measured. The scale used is known as the Kelvin scale, as it is based on a theoretical model that predicts the color that a black body radiator would glow as it was heated up. At the comparatively low temperature of 2,500°K the black body radiator would glow an orange-red. When it reaches 5,200°K the glow is a neutral white. By 7,000°K the glow has shifted to blue-white. Light that has a color bias that corresponds to a particular point on the temperature scale as the black body radiator heats up is said to have a similar color temperature.

White balance

Digital cameras can neutralize the color temperature of light by using their white balance facility. This works by shifting the colors in the image in the opposite direction to the color bias of the light. The light on an overcast day is very cool, for example. To compensate for this coolness, the white balance would add more orange to the image. There are usually several ways to set a camera's white balance. The easiest method is using the camera's Automatic white balance (AWB) setting. When set to AWB, any color bias is automatically detected and compensated for.

Color temperature	
1,800–2,000°K	Candlelight
2,800°K	Domestic lighting
3,400°K	Tungsten lighting
5,200°K	Midday sunlight
5,500°K	Electronic flash
6,000–6,500°K	Overcast conditions
7,000–8,000°K	Shade
10,000°K	Clear blue sky

Unfortunately, AWB isn't perfect. It can be fooled into adjusting white balance unnecessarily by large areas of a single color in an image. For more control, cameras offer a range of preset white balance settings represented by different symbols. These symbols are relatively universal and are shown below. Some cameras also allow the setting of a specific Kelvin value, often in steps of 100–200°K.

Ultimately, the finest control over color temperatures is achieved by setting a custom white balance. This is achieved in subtly different ways on different camera models. The general idea, however, is that an image of a white (or neutrally gray) surface is shot, illuminated by the same light as your subject (the surface filling the frame entirely). The camera then uses this image to calculate the correct white balance adjustment. Typically the custom white balance preset would then be set (the custom white balance is only applicable to the light the white surface was shot under—if you move to a different lighting set-up, a new custom white balance should be created).

Note
Setting the correct white balance is more important when shooting JPEG than RAW.

WB Symbol	Description
AWB	Automatic White Balance
☀	Daylight: Normal sunny conditions
🏠	Shade: When shooting in shadow
☁	Cloudy: Adds warmth to an image on overcast days
☀	Tungsten: Incandescent domestic lighting
〰	White fluorescent lighting
⚡	Flash
◢	Custom white balance

WHITE BALANCE

The eight images in the sequence use a different white balance setting. In many ways there is no right or wrong answer. The cooler blue settings are interesting and aesthetically quite pleasing. The "correct" white balance setting for this scene is arguably around 6,500–7,500°K.

2000°K

3000°K

4000°K

5000°K

6000°K

7000°K

8000°K

9000°K

Using light compositionally

Light is almost as important a part of a composition as your subject. The light you use should be sympathetic to, or even enhance, your subject.

Natural light

The sun is, by a very wide margin, the most important natural light source. Even the light from the moon is reflected sunlight. However, the quality of the sunlight (its color, strength, hardness, or softness) is altered to a greater or lesser degree by its passage through the Earth's atmosphere. Different wavelengths of the light are affected in different ways. The shorter, bluer, wavelengths are affected most of all, being scattered and absorbed more by the Earth's atmosphere than the longer, red wavelengths.

This is most easily seen over the course of a cloudless day. At daybreak, when the sun is on the horizon, the light passes obliquely through the Earth's atmosphere. This causes the blue wavelengths of light to be highly scattered and absorbed. The light that reaches us is therefore biased towards red, causing the warm light associated with daybreak. Another effect is that the intensity and contrast of the light are reduced. As the sun rises in the sky, less of the blue light is scattered and the red bias diminishes. By midday the light is far more neutral in color (though this does depend on latitude and time of year—in midwinter at higher latitudes the sun never rises high above the horizon and so the light stays comparatively warm all day), and both contrast and the intensity of the sunlight are at their highest. Past midday the sun tracks back towards the horizon and the light gradually warms up once more until the warmth reaches it peak when the sun is on the horizon again.

ATMOSPHERE
When the sun is on the horizon it passes through a thicker slice of the earth's atmosphere, which scatters blue light more—increasing the warmth of the light. At midday there is less scattering and the light is more neutral in color.

Canon EOS 1Ds Mk II, 24mm
lens, 1/8 sec. at f/16, ISO
100, Aperture priority mode,
evaluative metering

LIGHT

In the natural world the warmest light (in terms of color temperature)
is found at either end of the day. The amount of cloud can make a big
difference to the intensity and duration of the color. The evening when
I created this image was clear. The light was warm up until the sunset.
However, because there was no cloud in the sky the warmth quickly
faded once the sun had dipped below the horizon.

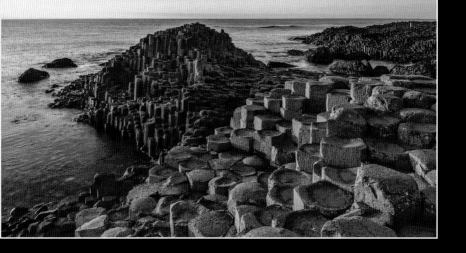

Clouds

Add clouds to a sky and the light from the sun is modified further. Clouds act as natural reflectors, lowering contrast by adding more light into the shadows. Clouds also add color to a sky when illuminated by the rising or setting sun. If cloud is in the right place it will also be illuminated when the sun drops below the horizon. The higher the cloud, the earlier or later this happens at sunrise and sunset respectively. High-altitude cloud can still display color up to half an hour after sunset.

When there is 100% cloud cover, the light from the sun is diffused. Contrast is extremely low, with shadows either indistinct or even invisible. The color of the ambient light is cooler than when the sun is shining directly. Typically the color temperature is approximately 6500°K and images need filtering (or the white balance altering) to avoid a cool blue cast.

Overcast light isn't ideal for all subjects. Wide-open vistas rarely benefit from such cool, soft light. However, woodland and close-up subjects suit overcast light. Portraits also work well, particularly as the subject doesn't need to squint or require light modifiers to soften unsightly shadows under overhanging facial features such as the nose or chin.

WOODLAND
In direct sunlight woodland can be a mess of highlight and shadow. The contrast range is higher than a camera can successfully record. For this reason, overcast light is often easier and more pleasing to work with.

Aerial perspective

Air isn't perfectly clear, since dust and other particles reduce clarity. The greater the distance between you (and your camera) and an object, the less detail you'll be able to resolve in that object due to a reduction in contrast. Another effect of distance is that the color of the object is less saturated and shifts towards the dominant background color. During the day this is typically blue, though when the sun is closer to the horizon the dominant background color can be a warmer color such as yellow or red. We understand instinctively that this reduction in contrast and change of color indicates distance. This effect is known as aerial perspective (or atmospheric perspective) for this reason.

In photography, aerial perspective can be exploited to simplify mountainous landscape images. Using a telephoto lens is a particularly effective way to isolate the various layers of the landscape, producing a stacked effect of abstract shapes. The effects of aerial perspective are more noticeable after several days of a stable, high-pressure weather system. The more dust that's trapped in the atmosphere, the more the reduction in contrast over distance.

EVENING
If the conditions are right, sunrise and sunset will tint the effects of aerial perspective yellow or red rather than the more typical blue.

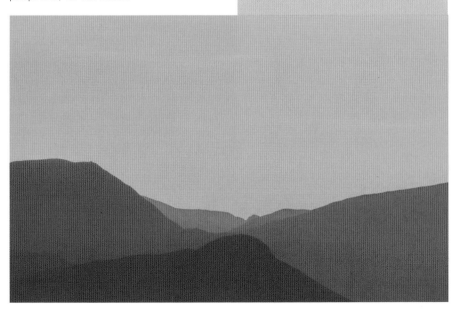

Artificial light

There are many kinds of artificial light, with an enormous variety both in color temperature and in intensity. The least intense (and also the warmest in color) is flame, from candles, matches, or fire. Household incandescent bulbs generate far more light for their size than flame. The light is also cooler (though still very warm in comparison to midday sunlight).

Fluorescent lighting is typically cooler still, and also tends to produce a softer light than both flame and incandescent bulbs. Fluorescent lighting is available in a variety of different color temperatures from warm-white (2,700°K) to neutral-white (3,000–3,500°K) and daylight-balanced (5,500°K). Some older fluorescent lamps have incomplete spectrums, requiring the use of filters or a custom white balance to accurately render colors when used as an illumination.

The coolest type of artificial lighting commonly used by photographers is flash. This lighting is neutral and is similar in color temperature to midday sunlight. This makes flash easy to use during the day as a fill-in light, though it can make the light appear cool or even cold when mixed with other forms of artificial lighting, such as incandescent bulbs.

Colored lighting (such as that used on neon signs) emits light from one particular wavelength only. This makes this light almost impossible to correct using white balance. However, in this instance you probably wouldn't want to. The vibrant colors of a neon sign are a large part of the visual impact of such lighting.

WARMTH
Tungsten lighting is warm. For outdoor scenes use a white balance between 3,500 and 4,000°K so that this attractive warmth isn't neutralized.

Canon EOS 7D, 50mm Lensbaby
lens, 5 sec. at f/8, ISO 100,
Aperture priority mode,
evaluative metering

ABSTRACTION

Light can be the subject of images too. This abstract image was created
by shooting the light from a streetlamp refracted through ice on a
window. The unusual shapes of the splashes of light were created by
moving the front element of a Lensbaby lens so it was no longer parallel
to the camera.

Canon EOS 1Ds Mk II, 17–40mm lens at 20mm, 8 sec. at f/13, ISO 100, Aperture priority mode, evaluative metering

DUSK

The optimal time to shoot city night scenes isn't at night. Shooting at dusk, roughly half an hour after sunset, will produce more pleasing results. At this time of day there is still color in the sky and, because the sky is still relatively light, the shape of building rooflines is still discernible.

Creative white balance

There are two approaches to setting white balance. You can be technically correct, so that white balance is set so that any color bias in the lighting is neutralized. Alternatively, you can use a color temperature setting that either maintains the coolness or warmth of a light source (you wouldn't want to neutralize the warm light of sunset for example) or that alters the overall color tint of an image to achieve a particular effect. Color has an emotional effect (see the section about color later in this chapter). By biasing the color temperature of an image in a particular direction you can create an emotional impact that wouldn't have been there otherwise. An overall warm tint is flattering to skin tone. It also has connotations of health and happiness. A cooler overall tint has the opposite effect. It's not particularly flattering and it conveys ill-health and unhappiness. This emotional manipulation through the use of overall color tint is often used in movies and on television.

PEOPLE
We can tell very quickly when the "wrong" white balance has been used in images of people. The top image looks far more natural than the one at the bottom.

Silhouettes

Silhouettes are created when your subject is backlit. It pays to keep things simple when you pick your subject. Choose one that doesn't have too complex a shape and that is recognizable from that shape. Think bold, hard shapes rather than subtle, soft ones. People tend to make better silhouettes in profile rather than looking directly at the camera. If possible, your subject should be in an open environment. There should be no distracting elements intruding into your subject's outline as this may make deciphering the silhouette more difficult.

Ideally there should be little or no light illuminating your subject from the front.

When shooting outdoors it's easier to create silhouettes when the sun is low on the horizon and the ambient light levels are relatively low.

In order to shoot the silhouette you may need to override your camera's exposure meter. The meter will probably try to expose your subject correctly causing overexposure of the background. If your camera has a spot meter, use this to expose for the background and then lock the exposure before recomposing. Alternatively, apply negative exposure compensation until the background is correctly exposed and your subject is in silhouette. Turn off automatic flash to prevent your camera lighting your subject.

AMBIGUOUS
Silhouettes can create pleasing ambiguity in which the size of your subject is difficult to discern.

Nikon D600,
70–300mm lens
at 70mm, 1/400
sec. at f/14, ISO
200, Aperture
priority mode,
evaluative
metering

FLARE

Shooting silhouettes usually means shooting
into light. If your subject is hiding the light
source then flare is unlikely. However, if the
light source is included in the image then
flare can become a problem. Keeping the lens
elements clean is one way to minimize the risk.
Not using filters at all is another. Filters add
another layer of glass (or plastic) to the optical
system, greatly increasing the likelihood of flare.

Color

Color is an important factor in how we perceive the world. Understanding how we react to color is another tool that can be used to compose a photo.

Color wheel

The colors in a digital image are create by mixing red, green, and blue in the right proportions—an absence of these colors makes black, and all three mixed together at their maximum values makes white. Red, green, and blue are referred to as primary colors. Different media use subtly different primary colors—for instance, a painter would regard red, yellow, and blue as primaries. Mix two of the primary colors at their maximum value and you produce a secondary color. Red and green mixed together produce yellow, green and blue produce cyan, and blue and red produce magenta. The relationships between the colors are seen most easily on a color wheel. The color wheel is also a useful tool for anticipating which colors work well together and which don't. This is known as color harmony, a subject we'll return to later in the chapter.

COLORS
Red, blue, and green are the primary colors when using the (aptly named) RGB model. When two adjacent primaries are mixed together equally (and at their maximum values) they produce the color exactly at the mid-point between the two primaries.

Qualities of color

Colors have three basic qualities: hue, saturation, and value. If you use Adobe Photoshop you may even have seen some of these terms referring to sliders that allow you to alter and select colors.

Hue is essentially a synonym for color. Red is a hue, as are yellow, green, blue etc. Scientifically, a hue can be described in relation to a particular wavelength of light. Red, for example, corresponds roughly to a wavelength of 700 nanometers.

The saturation of a hue describes its intensity or vibrancy. A vibrant hue is one that has no black, white, or gray mixed in. In RGB terms, 255, 0, 0 will produce a vibrant red. Add green and blue to the mix and the red becomes less vibrant—or more desaturated. A completely desaturated color is essentially gray. Saturated colors are inherently more eye-catching than less saturated colors.

Value describes the lightness or darkness of a color. The higher the value of a color, the closer it is to white. A yellow (255, 255, 0) therefore has a higher value than green (0, 255, 0). The lower the value, the closer the color is to black. Higher-value colors tend to be more eye-catching than lower-value colors.

> ### Note
> *Colors are said to be either "progressive" or "recessive" in the way in which they appear to come forward or recede in an image respectively. Warmer colors are typically progressive (with red being the most progressive color of all); cooler colors are typically recessive.*

VISIBLE
Warning signs often employ highly saturated warm colors because of their high visibility.

Impact of color

Different colors cause different psychological effects in the viewer—both positive and negative (both in images and in language—think of the many allusions that include color, such as "in the pink" or "red letter day"). By excluding or including certain colors you can control how an image is perceived and interpreted.

Color perception	
Color	**Effect**
Red	Positive: warm, exciting, energetic, stimulating, inviting, love, comforting
	Negative: aggressive, unsubtle, anger
Orange	Positive: warm, sensuous, passionate, fun
	Negative: frivolous, immaturity
Yellow	Positive: optimistic, emotional strength, spirit-lifting, friendly, creative, confidence
	Negative: fear, depression, irrational, frustrating
Green	Positive: harmonious, refreshing, natural, balanced, restful, peaceful, healthy
	Negative: bland, stagnant, static, passive, jealousy
Blue*	Positive: intelligence, serene, logical, cool, calm, reflective, trust, efficiency
	Negative: cold (emotionally), aloof, unfriendly, depression
Violet	Positive: spiritual, luxurious, authentic, truthful
	Negative: introverted, decadent
Brown	Positive: serious, stable, earthy, reliable, warm, strength
	Negative: unsophisticated, conventional
White	Positive: sterile, pure, clean, efficient, space, naivety
	Negative: cold (emotionally), unfriendly
Gray	Positive: solidity
	Negative: neutral, bland, boring
Black	Positive: security, sophisticated, substantial, infinite
	Negative: menacing, oppressive, cold (emotionally), heavy, suffocating, mourning

* Blue is the color most cited by men and women as their favorite.

Canon EOS 7D,
24–70mm lens at
40mm, 1/80 sec.
at f/4.5, ISO 1000,
Aperture priority
mode, evaluative
metering

FOOD

We're actively repelled by food that has a
blue tint. When shooting images of food
a touch of warmth goes a long way to
making the food look appetizing. Compare
the two halves of this image. Which do you
find more appealing?

Color harmony

In music a harmony is a series of notes that work well together. Color can also harmonize, often in surprising and unexpected ways.

Monochromatic color scheme

The simplest color combination is when variations of the same color are placed together (the variation coming from the changes in the relative brightness or saturation of the color). This is known as a monochromatic color scheme and although it's not a color harmony in the strictest sense, it is a combination you come across occasionally, particularly in nature (think of all the variations of green that can often be found together). Monochromatic color schemes never look unbalanced and look restful to the eye, particularly when blues or greens are used.

Analogous color harmony

Analogous color harmonies are composed of three to four colors that are adjacent to each other on a color wheel. Yellow, orange,

and green are analogous colors. The natural world is a good place to see analogous color harmonies. However, although they're pleasing and restful, analogous color harmonies aren't particularly exciting. The most effective way to use analogous color harmonies is to have one dominant color, a second less dominant, and the others used as support.

Triadic color harmony

A triadic color harmony uses three colors that are at an equal distance on a color wheel. The combination is vibrant, though you have to be careful to get the balance right between the colors. Generally, the best method of achieving this is to have one dominant color with the other two used equally as support.

Complementary colors

Complementary colors are found on opposite sides of the color wheel. When placed next to each other, complementary colors reinforce each other, neither color overpowering the other (hence the name). The result is often striking and dynamic, as color contrast is higher than with any other two-color combination. Warm and cool complementary colors often work well together.

Complementary colors are more usually found artificially than in nature. Designers and architects often use complementary colors for impact. However, when complementary colors are placed together, the results aren't subtle so they tend not to be used where a more restful ambience is required. There is one time when you see complementary colors together in the natural world, however: when a neutrally-colored object is lit by sunlight at sunrise or sunset, the lit side will be red-orange. If there are no clouds, the shadow side will be tinted blue by the ambient light from the blue sky.

FLOWERS
Other natural sources of complementary colors are certain flower species. These purple foxgloves are complementary to the surrounding green foliage.

Nikon D70, 50mm
lens, 1/320 sec. at
f/9, ISO 200, Aperture
priority mode,
evaluative metering

COMPLEMENTARY

Orange and blue are complementary colors,
producing an arresting contrast when
used together. When creating this image I
deliberately excluded any other details and
colors to simplify the composition and to
create the most color impact.

Warm and cool color harmonies

An image that is dominated by the warm colors such as yellow, orange, or red is said to have a warm color harmony. Images that have a cool color harmony are dominated by cool colors such as blue or green. As previously mentioned, warmer colors are progressive and cooler colors are recessive. Creating a warm color harmony image will therefore make your subject or scene appear closer than when a cool color harmony is used.

Split-complementary colors

Split-complementary colors (right) are similar to complementary colors. However, instead of two colors, there are three: a base color and two colors that are adjacent to its complement. It's a strong, bold color scheme, though not as bold and with less tension than when two complementary colors are used together.

Split-complementary colors	
Base color	**Color combinations**
red	yellow-green and blue-green
orange	blue-green and blue-violet
yellow	red-violet and blue-violet
green	red-orange and red-violet
blue	red-yellow and red-orange
violet	yellow-green and yellow-orange

Nikon D600, 100mm macro lens, 1/160 sec. at f/4, ISO 100, Aperture priority mode, evaluative metering

COOLER

Garden flowers are more typically warmer in color. Bluebells are an interesting exception and, when coupled with green foliage, allow the creation of images with a cool color harmony.

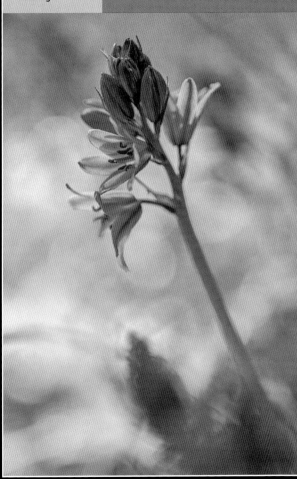

Tetradic color harmony

A tetradic color harmony is made up from two sets of complementary colors (four colors in total). On a color wheel the relationship between the colors in a tetradic color harmony is shown by a rectangle. The key to using a tetradic color harmony is not to use the four colors equally, but to use one of the colors as the dominant color and the other three as support (being careful to keep the warm and cool colors balanced—warm colors are visually heavier than cooler colors). Tetradic color harmonies are visually striking and eye-catching, and arguably more suited to boldly colored artificial subjects than to natural scenes.

Square color harmony

A square color harmony is similar in principle to a tetradic color harmony in that four complementary colors form the basis of the harmony. It differs in that the four complementary colors are spaced equally around the color wheel. As with tetradic color harmony, it's more visually pleasing if you use one of the colors as the dominant color and the other three as support.

BOLD
Stained-glass windows are a good place to see the bold use of color harmonies such as the tetradic.

Progressive

Red has more impact in an image than cooler colors such as blue and green. Compare the main image to the smaller altered image at right. Much of the impact has been lost and the image feels flatter.

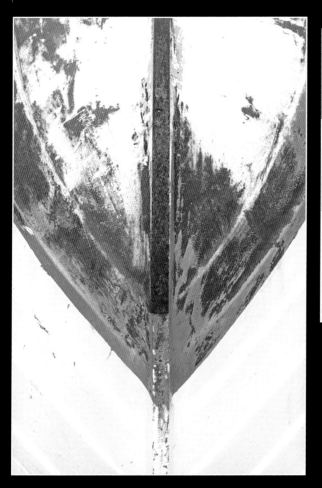

Canon EOS 1Ds Mk II, 100mm lens, 1/10 sec. at f/10, ISO 100, Aperture priority mode, evaluative metering

Soft

The soft light of an overcast day is ideal for more delicate subjects such as flowers. If you can't wait for an overcast day you can create your own soft light by casting a shadow over your subject. I often use a large reflector for this purpose.

Nikon D600, 100mm macro lens, ,1/1250 sec. at f/4.2, ISO 400, Aperture priority mode, evaluative metering

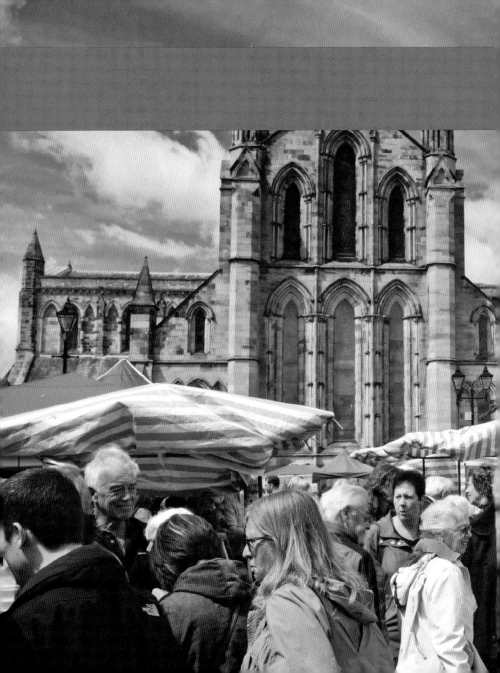

CHAPTER 5 PRACTICALITIES

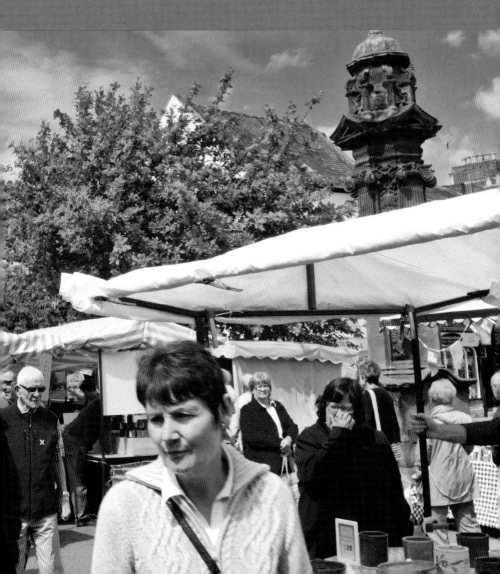

Practicalities

There's more to making an image than pointing a camera at something and pressing the shutter button. You also need to consider the effects of exposure functions such as shutter speed and aperture.

Being in control

Composing an image means thinking about all aspects of how it is created. The way the image is exposed is as much a creative act as deciding on a lens' focal length and the correct viewpoint. Exposure allows you to control the tonal range of the image. This has a profound effect on how an image is perceived. Darker tones have a different meaning emotionally than lighter tones. Understanding how to control exposure is therefore a skill that's vital to the creative photographer.

Learning about exposure involves understanding the effects of different shutter speeds and aperture settings on an image.

A painter learns how paints can be mixed to achieve the desired result. Learning how shutter speed and aperture are interrelated is the equivalent for the photographer.

This chapter covers the above as well as other aspects of image making, such as focusing. Many of the concepts are slightly counter-intuitive and there's no shame if they don't immediately make sense. The key is experimenting and learning from experience. One advantage of digital photography is that shooting functions settings such as shutter speed and aperture are recorded in an image's metadata. Using this data is a good way to understand why an image has worked and, sometimes more usefully, why it hasn't.

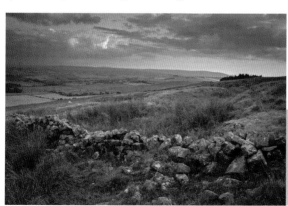

EXPOSURE *(Opposite)*
A good composition is one link in the chain to producing a successful image.

MOOD
Functions such as exposure and a camera's color controls can be adjusted to suit the particular mood that you want to convey.

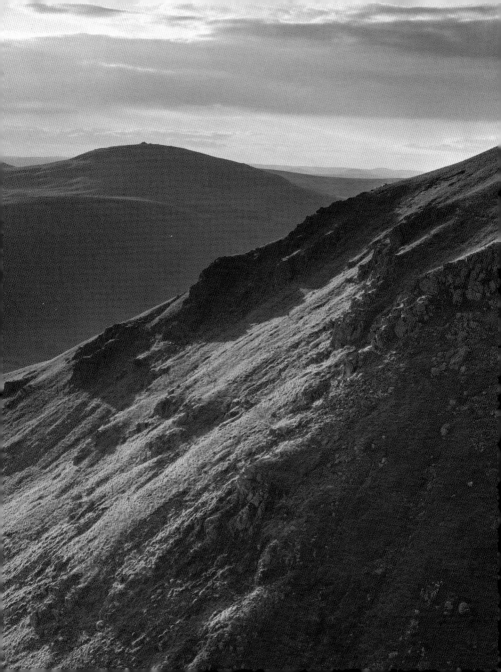

Exposure

The word exposure has two meanings. To make an exposure is to let light into a camera to form a photographic image. Exposure can also mean the act of working out how much light is required to make a successful photographic image.

First principles

A camera is essentially a box with a hole in one side and a light-sensitive surface inside on the opposite side to the hole. In a digital camera this light-sensitive surface is the sensor. The sensor is protected from light by the use of a shutter, which can be opened and closed. When the shutter is opened, light falls onto the sensor to form an image. The shutter is held open for a very precise period of time, known as the shutter speed.

Most cameras have a lens that is used to precisely focus light (the exception to this is the pinhole camera, which relies entirely on the focusing effects of the pinhole to create a relatively sharp image). Lenses have a variable aperture inside so that the amount of light passing through the lens can be controlled.

The length of the shutter speed and the size of the aperture combined allow an exact amount of light to fall onto the light-sensitive surface. The act of controlling the amount of light needed to form an image is known as setting the exposure. A third factor in setting the exposure is the sensitivity of the sensor to light. This is controlled by the ISO setting. The higher the ISO, the less light is required to make an image.

METERED
Working out how much light is required to make an image isn't too arcane a business. Modern camera meters are very reliable and consistent.

Exposure triangle

The word stop has several meanings in photography. Probably the most common use is to indicate that either twice the amount of light has been allowed into a camera (when the exposure is said to have been increased by one stop) or that half the light has been let in (when the exposure has been decreased by one stop).

Shutter speed, aperture, and ISO are linked. The easiest way to visualize this is to imagine shutter speed, aperture, and ISO at separate corners of a triangle. If you alter one, either or both of the other two must be altered to maintain the same level of exposure. If we think of this in terms of stops, halving the amount of light that reaches the sensor by halving the shutter speed means letting twice as much light through the aperture, or doubling the sensitivity of the sensor by altering the ISO (or adjusting the aperture and ISO by half a stop each) to compensate.

TRIANGLE
If you change one exposure variable at the corner of the triangle, you'll also need to alter one or both of the other two variables to maintain the same exposure.

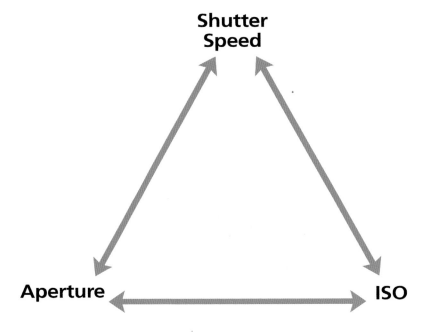

Shutter Speed

Aperture **ISO**

Metering

A digital sensor needs a very precise amount of light in order to make a correctly exposed image. The required shutter speed and aperture (for the ISO setting used) is determined by the exposure meter in your camera. This meter is a reflective meter, so called because it measures the amount of light that is reflected towards the camera by the scene being measured.

Generally, reflective meters are accurate. However, they can be fooled by scenes that have a higher- or lower-than-average reflectivity. An ideal scene for a reflective meter is one that reflects roughly 18% of the light that falls on it. This is equivalent to a mid-gray card, exactly like the one in the cover of this book. A good example of a scene that has a higher-than-average reflectivity is one covered in snow. Snow scenes have a tendency to cause underexposure because the meter is trying to create an exposure that matches the overall

tonal range of the gray card. In contrast, a lower-than-average scene will tend to cause overexposure for exactly the same reason.

One way around the problem is to use a camera's spot-metering facility to precisely meter from an element in the scene that has a reflectivity closer to the average. Another solution is to use exposure compensation to adjust the suggested exposure. Typically a snow scene requires 1.5 to 2 stops of positive compensation.

Note
You could also use a handheld incident light meter. These measure the light that falls onto a scene rather than the light that is reflected. This makes incident meters less prone to the effects of a scene's reflectivity.

SNOW
To ensure correct exposure for this snow image, I used the camera's spot meter to meter from the gray stone of the wall.

Shutter speed

The shutter speed you choose will be largely irrelevant if your subject is static. However, add movement to a scene and the shutter will determine how that movement is captured.

Slicing time

The various shutter speeds your camera can shoot are very precise measures of time. Cameras vary in the range of shutter speeds that they offer. A typical system camera has a range of 1/4000 to 30 sec., and often a Bulb mode which allows you to lock the shutter open for minutes, or even hours. Compact cameras tend to have a smaller range, omitting the faster shutter speeds and often limiting the longest shutter speed to a few seconds.

As mentioned previously, a stop is an indicator that the amount of light has been either doubled or halved. With shutter speed this is relatively easy to see. A shutter speed of 1/500 is twice as fast as 1/250, so that half as much light is let through the shutter. But 1/500 lets twice the light through that a shutter speed of 1/1000 would.

Movement

The shutter speed you choose needs to be considered carefully for a number of reasons. Shutter speed affects the aperture or ISO setting required, so you'll need to think about the effects of depth of field or noise on your image. If you're handholding your camera, you'll also have to be aware that camera shake is a greater possibility the lower the shutter speed.

FROZEN
Although this aircraft was traveling at over 300mph (480kph), it appears frozen because of the fast shutter speed (1/2000 sec.) I used.

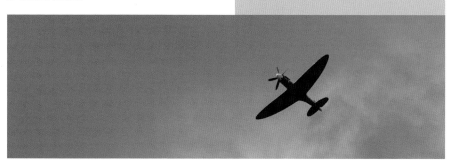

The shutter speed you choose is also important if there is any movement in the scene. The shutter speed controls how movement is recorded in the final image. The faster the shutter speed, the more that movement is "frozen." Conversely, slower shutter speeds create more blur. Use a sufficiently long shutter speed and your moving subject may not even be visible in the final image at all.

Freezing time

There are four variables that need to be juggled when selecting a shutter speed to freeze movement: the speed and direction of the movement, the focal length of the lens and the camera-to-subject distance. See the tables opposite for example scenarios and relevant shutter speeds.

The more the subject fills the frame, either because of proximity to the camera or due to the use of a long focal length lens, the faster the shutter speed you'll need to freeze movement. The smaller the subject within the frame (or the wider the focal length of the lens), the slower the shutter speed you'll be able to use and not see blur. A subject traveling across the frame will also need a faster shutter speed than one traveling towards or away from the camera. Finally, and most obviously, the faster the subject is traveling, the faster the shutter speed you'll need. However, the subject's speed is relative. If you're shooting a vehicle from another vehicle, it's the difference in speed between the two that's important.

RELATIVE
Even though this yacht almost fills the frame I was able to use a shutter speed of 1/500 sec. to freeze its movement. This is because I was on another boat traveling in the same direction and at the same speed.

Freezing movement with 35mm lens (full-frame equivalent)

Subject speed	Distance	Shutter speed	Distance	Shutter speed
1mph / 1.6kph	5ft / 1.5m	1/400 sec.	10ft / 3m	1/200 sec.
2mph / 3.2kph	5ft / 1.5m	1/800 sec.	10ft / 3m	1/400 sec.
4mph / 6.4kph	5ft / 1.5m	1/1500 sec.	10ft / 3m	1/800 sec.
8mph / 12.8kph	5ft / 1.5m	1/3000 sec.	10ft / 3m	1/1500 sec.
15mph / 24kph	10ft / 3m	1/2500 sec.	50ft / 15m	1/500 sec.
30mph / 48kph	10ft / 3m	1/5000 sec.	50ft / 15m	1/1000 sec.
70mph / 113kph	50ft / 15m	1/2500 sec.	100ft / 30m	1/1500 sec.
150mph / 242kph	100ft / 30m	1/2500 sec.	500 ft / 152m	1/500 sec.
400mph / 644kph	500ft / 152m	1/1500 sec.	1000ft / 300m	1/800 sec.
1000mph / 1600kph	500ft / 152m	1/4000 sec.	1000ft / 300m	1/2000 sec.

Freezing movement with 50mm lens (full-frame equivalent)

Subject speed	Distance	Shutter speed	Distance	Shutter speed
1mph / 1.6kph	5ft / 1.5m	1/500 sec.	10ft / 3m	1/250 sec.
2mph / 3.2kph	5ft / 1.5m	1/1000 sec.	10ft / 3m	1/500 sec.
4mph / 6.4kph	5ft / 1.5m	1/2000 sec.	10ft / 3m	1/1000 sec.
8mph / 12.8kph	5ft / 1.5m	1/4000 sec.	10ft / 3m	1/2000 sec.
15mph / 24kph	10ft / 3m	1/4000 sec.	50ft / 15m	1/800 sec.
30mph / 48kph	10ft / 3m	1/8000 sec.	50ft / 15m	1/1500 sec.
70mph / 113kph	50ft / 15m	1/4000 sec.	100ft / 30m	1/2000 sec.
150mph / 242kph	100ft / 30m	1/4000 sec.	500ft / 152m	1/800 sec.
400mph / 644kph	500ft / 152m	1/2000 sec.	1000ft / 300m	1/1000 sec.
1000mph / 1600kph	500ft / 152m	1/5000 sec.	1000ft / 300m	1/3000 sec.

Freezing movement with 100mm lens (full-frame equivalent)

Subject speed	Distance	Shutter speed	Distance	Shutter speed
1mph / 1.6kph	5ft / 1.5m	1/1000 sec.	10ft / 3m	1/500 sec.
2mph / 3.2kph	5ft / 1.5m	1/2000 sec.	10ft / 3m	1/1000 sec.
4mph / 6.4kph	5ft / 1.5m	1/4000 sec.	10ft / 3m	1/2000 sec.
8mph / 12.8kph	5ft / 1.5m	1/8000 sec.	10ft / 3m	1/4000 sec.
15mph / 24kph	10ft / 3m	1/8000 sec.	50ft / 15m	1/1500 sec.
30mph / 48kph	10ft / 3m	1/16000 sec.	50ft / 15m	1/3000 sec.
70mph / 113kph	50ft / 15m	1/8000 sec.	100ft / 30m	1/4000 sec.
150mph / 242kph	100ft / 30m	1/8000 sec.	500ft / 152m	1/1500 sec.

Creative blurring

Although it's possible to freeze movement entirely, it's not always aesthetically appropriate. We expect to see some blurring of movement. Therefore, rather ironically, freezing movement entirely can actually make an image look static and oddly lifeless.

Photographers often use longer shutter speeds to deliberately add blur to movement for creative effect. Probably the most common example of this is using long shutter speeds to blur the movement of water. Often this is a necessary consequence of shooting in low light using a small aperture for reasons of depth of field.

There is no right or wrong answer to the blurring of movement. It's largely a matter of preference and will depend on the image you wish to create (see the table opposite for a few common examples). The longer the shutter speed, the more abstract the moving subject will be. This works well with colorful, contrasty subjects, but less so with subjects that are more monochromatic or low in contrast (the more abstracted your subject, the more that color becomes the primary subject of the image). A particularly abstract use of long shutter speeds is the recording of light, typically from moving cars, to produce trails that flow through the image space.

TRAILS
The light from fireworks exploding can be recorded as a distinct trail by using a shutter speed of 1–10 seconds.

Achieving slow shutter speeds

It's often easier to achieve faster shutter speeds than slower ones. Achieving a fast shutter speed requires the use of an aperture close to the lens' maximum, using a higher ISO, or combining the two. Setting a low shutter speed (without causing overexposure) means using a small aperture and a low ISO. However, in bright light this can be difficult, particularly as some cameras use ISO 200 as the lowest ISO, and the fact that it's not advisable to use the smallest apertures due to the effects of diffraction (described later in this chapter).

Fortunately, there is a solution. Neutral density (ND) filters reduce the amount of light that passes through the lens to the sensor—think of them as sunglasses for cameras. ND filters come in a variety of strengths from 1-stop filters to super-dense 10- or 12-stop filters. The strength of the required filter is determined by the difference between the "correct" shutter speed and the shutter speed needed to achieve the desired effect. For example, if the shutter speed is 1/60, but you want to use a shutter speed of 1/2 second, you'd need to fit a 5-stop filter to the lens (or a combination of filters that equals 5 stops).

Suggested shutter speeds to blur movement

Subject	Shutter speed
Moving traffic	1/100–1/50 sec.
Person walking	1/50-1/15 sec.
Waterfalls	1/4 sec.
Waves (slight blurring)	1 sec.
Firework trails	1–10 sec.
Clouds	8 sec.
Waves (more blurred)	15 sec.
Traffic light trails	30–60 sec.
Waves (form entirely lost)	1–2 sec.
Star trails	>10 min.

Panning

For subjects that travel across the image space there's another technique for conveying a sense of movement: panning. When the camera is static and the subject moves, the subject will be blurred when a relatively long shutter speed is used. However, by moving the camera to follow the subject (a motion referred to as panning) the subject will be sharp, but the background will be blurred.

To try this effect you'll need to choose a subject that either moves horizontally or vertically across the image space (panning doesn't work with subjects that are moving towards or away from the camera). Make sure your footing is stable, and hold your camera to your eye with your elbows tucked in (this makes the camera more stable as you pan). Turn your upper body in the direction from which your subject is approaching. Follow the movement of the subject with your camera as it comes towards you, turning your camera in a smooth arc. Press the shutter button down to begin the exposure when the subject is closest to you. Continue to follow the movement smoothly as the camera exposes and for a short time afterwards.

The correct shutter speed to use depends on the speed at which your subject is moving and the effect you want to create. The faster the shutter speed you use, the less blurred the background. The longer the shutter speed you use, the more blurred the background and the sooner you'll need to press the shutter button after you begin panning. Experiment with shutter speeds between 1/8 sec. and 1/125 sec. initially and then adjust as necessary.

SPEED
Shooting a panned image is a good way to convey the speed of your subject.

Canon EOS 7D, 17–40mm lens
at 28mm, 1 sec. at f/16, ISO 100,
Aperture priority mode, evaluative
metering

LOW LIGHT

When ambient light levels are low, shutter speeds will
tend to be long, particularly if you want to use a small
aperture and a low ISO setting. When shooting scenes
dominated by water this is often no bad thing.

Aperture

Aperture not only controls how much light passes through the lens, but also the amount of apparent sharpness in an image.

Sharpness

The phrase "point of focus" doesn't tell the entire story. When you focus you actually create a plane of sharpness parallel to the camera. So, if you were to focus on something flat and perfectly parallel to the camera —a wall, say—the wall would theoretically be sharp across the entire image space. If you refocus, this plane moves closer to or further from the camera, depending on the direction in which you move the focus. Everything in front or behind the point of focus would be unsharp or out of focus.

Fortunately, there's more to a camera lens than this. Inside the lens there is an aperture, the size of which can be adjusted very precisely. The size of the aperture is measured in f/stops, represented by f/ and a suffix number. Slightly counterintuitively, the larger the suffix number, the smaller the aperture. A typical aperture range on a lens would run f/4 : f/5.6 : f/8 :

f/11 : f/16 : f/22, with f/4 being the largest aperture and f/22 the smallest. Each f/stop value on a lens represents a difference of one-stop in the amount of light that passes through the lens. In the scale quoted, f/5.6 will allow in half as much light as f/4, but twice that of f/8.

The size of the aperture affects how much of an image is acceptably sharp. This effect is known as the depth of field. Depth of field extends twice as far behind the focus point as it does in front (so more towards the background than the foreground).

Note

Most modern lenses allow aperture to be adjusted in half- or third-stop amounts: f/4.5 and f/5 would fall between the whole-stop values of f/4 and f/5.6, for example.

APERTURE
A manual-aperture lens at f/1.7 (left) and at f/16 (right).

The smaller the aperture, the greater the depth of field and therefore the more the image appears to be sharp from the foreground to the background (though see the note about diffraction on page 154).

As well as the aperture, there are two other factors that determine the extent of depth of field. The first is the focal length of the lens you use. The shorter the focal length of the lens, the more inherent depth of field there is at a given aperture. This is the main reason why digital compact cameras (with their small focal length lenses) create images that appear to be sharp throughout the image. It's also why it's often difficult to throw parts of the scene out of focus.

The second factor that determines depth of field is the camera-to-subject distance. The closer your subject is to the camera lens, the less depth of field you will be able to achieve. This is one of the main problems that need to be faced when shooting macro.

Macro photography involves very small camera-to-subject distances. Depth of field is often very restricted even when using small apertures. There are techniques—such as focus stacking—that can be used to reduce these problems, but even these techniques aren't perfect and require a technically rigorous approach to shooting.

APERTURE
Landscape photography often requires the use of small apertures to achieve front-to-back sharpness.

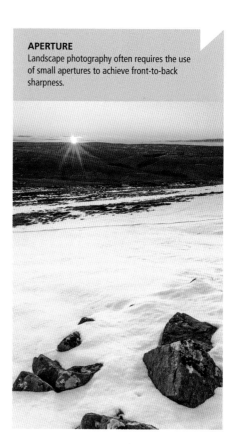

Note

Focus-stacking is a technique in which a large number of images of a subject are shot with the focus adjusted slightly between each shot (typically focusing at the front of the subject and then gradually working through to the back). The shots are then blended together to create a final image that has greater front-to-back sharpness than would be achievable otherwise.

Nikon D600, 50mm lens, 1/100 sec. at f/3.5, ISO 1600, Aperture priority mode, evaluative metering

Depth of field is limited when the camera-to-subject distance is small and a large aperture is used. In this situation focusing has to be very precise. Even a small error in focusing can ruin a shot. Zooming into a Live View display is a very effective way of checking critical focus.

Exposure effects

You don't have to shoot images with an average spread of tones. Exposure can be used to affect the mood of an image by restricting the tones to a narrow band.

High and low key

Images that are mainly composed of light tones (with few or no middle to dark tones) are referred to as "high-key" images. Images that mainly comprise dark tones (with few or no middle to light tones) are referred to as "low-key" images.

The lack of dark tones in a high-key image makes it feel more open and airy. Typically, high-key images are associated with romance, innocence, and optimism. It's a common, almost clichéd, way to shoot portraits, particularly of women and children.

Low-key images are more brooding and atmospheric. They are associated with sadness, pessimism and other negative emotions. However, a low-key approach is often used in product photography, mainly to add a sense of mystery to the product. The technique is generally employed in so-called "teaser" campaigns before the release of the new product.

Exposure

One way to achieve high- or low-key exposure is to use exposure compensation to over- or underexpose your images respectively. However, this is often unsatisfactory as it's all too easy to clip the highlights or shadows. A better method is to modify the light that illuminates your subject.

DELICATE
High-key exposure is particularly effective when shooting delicate subjects such as flowers.

When shooting high-key images this means adding more light into the shadows. The simplest way to do this is to use a reflector to bounce light into the shadows as required. The reflector could be a sheet of card, though commercial reflectors are more effective and relatively inexpensive.

A more effective way to shoot a high-key image is to use additional lighting such as flash or studio lights to lighten the shadows. The lighting has to be soft, so the lights will need to be diffused by the use of reflectors or softboxes. The additional lighting shouldn't overpower your main source of illumination. The closer in strength the additional lighting is to the main lighting, the lighter the shadows will be, but the greater the risk that the image will look flat.

Low-key images require you to take the opposite approach by actually stopping light from reaching certain areas of the subject. You can do this either by using sheets of card to shade your subject or by fitting snoots and barn doors to your lighting (a snoot is a tube that directs the light from a flash or studio light; a barn door is a set of four flaps that can be opened or closed to precisely direct light). Using a hard light source is also a good way to create a low-key image. The harder the light, the more defined and dense the shadows will be.

MOODY
This image was shot using a flash with a snoot added to direct the light very precisely on the fly. Compare this to the image on page 86. It's the same fly, just lit in a completely different way.

Canon EOS 7D,
17–40mm lens,
1/160 sec. at f/13,
ISO 200, Aperture
priority mode, spot
metering

LOW-KEY

Images exposed for a low-key effect will look
more moody and, with the right viewpoint,
more menacing. In "normal" light this is an
interesting, if striking, sculpture. In overcast
conditions and with slight underexposure, it
takes on a more threatening aspect.

Focusing

Focusing combined with an appropriate aperture are the two controls that allow you to select how much or how little an image is sharp.

Hyperfocal distance

The smaller the aperture, the greater the depth of field. Therefore, you'd think it perfectly logical that using a lens' minimum aperture would create the maximum sharpness across the image. To a certain extent that's true. Depth of field is at its maximum extent at minimum aperture. Unfortunately, another optical effect—diffraction—starts to rob an image of sharpness (or more accurately, image resolution) when using smaller apertures. Diffraction is caused by light being randomly scattered as it strikes the edges of the aperture blades. This scattering softens the image. The smaller the aperture, the more the scattering is noticeable and the softer the image.

Ideally you should use the largest aperture possible that creates the required depth of field. Fortunately, depth of field can be maximized for a particular aperture by focusing the lens to the hyperfocal distance. When the focus point of a lens is set to the hyperfocal distance, the image will be sharp from half that distance to infinity.

To complicate matters, the size of the sensor has to be taken into account when calculating the hyperfocal distance; sensor size also has a bearing on how quickly the effects of diffraction are noticeable—smaller sensors are far more prone to diffraction than larger sensors. The sensor size affects a variable known as the "circle of confusion." Fortunately, it's not strictly necessary to know what your camera's circle of confusion value is.

FOCUSED
The greater the distance between the foreground and the background, the more critical choosing the right aperture becomes.

If you have a smart phone or iPod there are many apps available that can calculate the hyperfocal distance of a particular camera (or sensor size), lens focal length, and aperture.

Differential focusing

Front-to-back sharpness isn't strictly necessary for every image you make. Often it's equally effective to use a shallow depth of field to isolate your subject. However, this does not mean that the background (if this is the area that is out of focus) is irrelevant. It should still relate to your subject in some way. It may be out of focus, but it shouldn't detract from or jar with your subject.

Differential focus is also useful to convey depth. When we look at something, everything else is out of focus (unless it's in the immediate vicinity of the thing we're looking at).

Differential focusing mimics the way we see more closely than front-to-back sharpness.

The technique works more effectively when using a longer lens (particularly on a compact camera—you'll need to use maximum zoom). To use the technique, set the aperture close to the lens' maximum (using Aperture priority or Manual exposure). Next, focus precisely on the area of the scene you would like to be sharp. The closer this is to the camera, the more out of focus the background will be. As you're using a large aperture you should be able to use a relatively fast shutter speed, allowing you to handhold the camera. However, using a tripod and a zoomed Live View display is a good way to achieve more accurate focusing.

DISTANCE
There's no reason for the foreground not to be the out-of-focus area. This was achieved in this image through the use of a telephoto lens, a large aperture, and precise focusing on the arch at the end of the bridge.

Bokeh

The word bokeh is of Japanese origin and is used to describe the aesthetic qualities of the out-of-focus areas in an image, particularly the highlights. Different lens designs render out-of-focus areas in different ways. Typically lenses that are said to have "good" bokeh have circular apertures. This is usually determined by the number of blades in the aperture: the greater the number of blades, the more circular the aperture. However, some lenses employ curved aperture blades that are more circular than standard blades. The number of aperture blades is therefore only an approximate guide to the quality of a lens' bokeh. Lenses with more hexagonal apertures are generally regarded as having poor bokeh. Typically prime lenses have better bokeh than zooms, largely because there is less compromise required when designing a prime than a zoom. A lens with "good" bokeh will produce smooth out-of-focus areas. Highlights (if there are any) will be round and not polygonal.

Note
If you regularly shoot with small apertures to maximize depth of field it's likely that a lens' out-of-focus characteristics are largely irrelevant.

SMOOTH
Ideally out-of-focus highlights should be round not polygonal.

Tilt-and-shift lenses

Tilt-and-shift lenses are designed so that the front lens element can be angled relative to the camera (either forwards and backwards or left and right) as well as shifted (up and down or left and right). This has a number of applications. Shift allows you to keep the camera parallel to a tall subject and, by moving the image circle, to keep the top of the subject within the frame. This helps to avoid an optical effect known as converging verticals, where tipping the camera back to fit the subject into the frame causes the subject to appear to be falling backwards. The name refers to the fact that vertical lines in architectural subjects no longer look parallel, but appear to be converging to a point.

Tilt is more subtly useful. By tilting a lens element you alter the angle of the plane of focus. Tilted one way, the plane of focus can be made to pass through several elements in a scene, rendering them sharp even if they are at different distances to the camera. This technique (known as the Scheimpflug principle) is very effective at reducing the need for very small apertures to ensure front-to-back

sharpness. However, tilt the lens element the other way and sharpness can be restricted to a very small slice of the image, smaller even than when maximum aperture is used. This causes a curious effect where the image resembles a model scene. It's such a compelling visual phenomenon that many cameras now offer a pseudo-tilt option, which mimics the effect through in-camera processing.

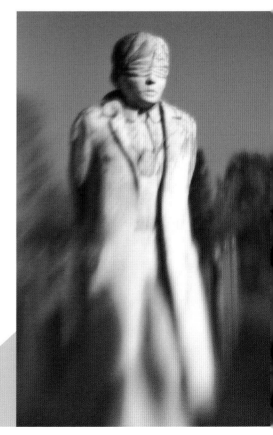

LENSBABY
Lenses made by Lensbaby allow you to restrict the range of sharpness in an image by moving the front lens element. The result is far less sharp and more dream-like than a true tilt-and-shift lens.

People

When we look at a portrait of a person we typically look at the eyes first—eyes have a high visual weight in comparison to other facial features. We therefore find it disconcerting if the eyes are out of focus, particularly if other facial features are sharp. Focusing on the eyes (or eye if only one is visible) is a good habit to get into. Unfortunately, this is often easier said than done. Eyelashes can fool a camera's AF system into focusing in the wrong place. This may not be critical if you're using a relatively small aperture. However, if you're using the differential focusing technique you may find that depth of field is insufficient to cover even the short distance between the tips of the eyelashes and the eye itself—this is particularly true when using a long focal length lens and if you're close to your subject. Live View, and the ability to zoom into the live image, is invaluable for checking critical focus when shooting portraits. Even then, it's worth checking focus again after shooting by zooming into the saved image and then reshooting if necessary. It doesn't take much movement of your subject's head before you press the shutter button for focus to be out.

FOCUS POINT
This image was shot with a 100mm lens at f/4.2. Because the depth of field was so limited I focused precisely on the eye by moving the camera's focus point.

EYES

It's a cliché that some portraits have eyes that follow you around a room, but it happens to be true. If a subject is looking directly at the camera they will appear to stare at the viewer of the resulting image. It's a psychological phenomenon that can be exploited to give your people shots impact and an arresting directness.

Panoramic images

Shooting panoramic images once meant the purchase of specialized and expensive photography equipment. Digital has changed all that. Now panoramic images can be created using inexpensive cameras and the correct software.

Definition

One definition of a panoramic image is that one dimension should be significantly longer than the other. There is no absolute consensus on what aspect ratio makes an image panoramic. If you're used to shooting the squarish rectangle of a compact or Four Thirds camera, the 3:2 aspect ratio of a DSLR can seem semi-panoramic. However, for the sake of simplicity, an image with an aspect ratio of 16:9 is a better starting point. Another definition of a panoramic image is that it is an image with a wide field of view (and it is often referred to as wide-format photography for that very reason).

Before the advent of digital cameras there were a number of specialized cameras that could shoot in panoramic format, the Hasselblad Xpan probably being the best known. Today, anyone can create panoramic images digitally in one of two ways. The simplest way is to crop an image after shooting. Unfortunately, this does involve losing much of the image's resolution, limiting the size an image can be printed without a noticeable drop in quality. A better solution (though one that takes more planning) is to shoot a number of images sequentially, moving the camera left or right (or even up or down) between each shot. These individual images are then "stitched" together later in postproduction.

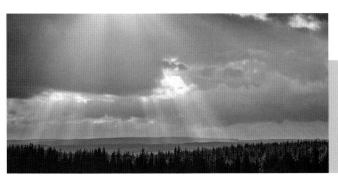

CROPPED
This image was cropped from a standard 3:2 image file. There wasn't time to shoot a sequence as the sky was changing too quickly.

Shooting to create panoramic images

Consistency is the key when shooting images for panoramic stitching. Ideally the entire sequence of images should be shot using the same exposure settings, and if you're shooting JPEG, functions such as white balance should be consistent too—these are more easily adjusted in postproduction when shooting RAW. The easiest way to be consistent is to shoot in Manual exposure mode (with a fixed ISO) using a custom white balance (rather than Auto). Another function that should remain the same throughout the sequence is the focus distance—switching to manual focus is best.

Composing a panoramic using the stitch method takes a certain amount of imagination. You can't see through the viewfinder what the finished panoramic image will look like. The first thing to decide is where the panoramic will start and end. You'll also need to decide (if it's a horizontal panoramic) what details top and bottom you want to include.

SEQUENCE
A sequence of seven images shot with the intention of creating a stitched panoramic. Note the overlap between each image in the sequence.

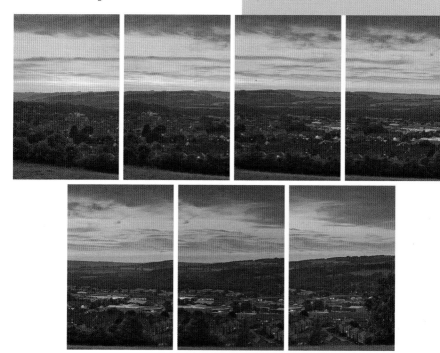

It pays to be conservative and shoot more than is strictly necessary. Anything that isn't needed can be cropped off later, but you can't add something that wasn't shot in the first place.

It may sound odd, but if you're shooting a horizontal panoramic sequence it's better to keep the camera vertical and vice versa. Shooting this way will require you to shoot more images, but it does give you more scope for cropping later. The width of the panoramic and the focal length of the lens you use will be factors in the number of images you need to shoot too.

As you shoot your sequence, you should try to overlap each image by roughly a third. This is necessary for your postproduction software to find common points of reference between the images. If you don't overlap you may find that the software can't stitch your images together.

It's possible to shoot a panoramic sequence handheld if you're careful. The key is to try to keep your camera as level as possible as you shoot. If you vary the height during the sequence it may end up being difficult to crop a decent sized rectangular image later. For this reason it's far easier to shoot the sequence with the camera mounted on a tripod, though you do need to ensure that the tripod is level using a spirit level before you start. The more images you shoot, the more important it is to keep your camera level during the sequence.

Strangely, wide-angle lenses aren't ideal for shooting a panoramic sequence. Lens distortion and slight changes in perspective can be a

STITCHED
The stitched sequence of the seven vertical images. Note the ragged edge and foreground. This was cropped out in the final panoramic.

big problem in the postproduction phase. A moderate focal length or even a telephoto lens will suffer less from these problems.

One problem you may encounter when shooting your panoramic sequence is movement between images. Water, particularly tidal water, is one problem area. You may find imperfect joins once the image has been stitched. For this reason it's worth inspecting the stitched image at 100% magnification to check that everything is seamless. If it isn't, use a clone tool to patch up the joins. Shoot your sequence as quickly, but as smoothly as possible.

Stitching

Once you have created your sequence you'll need to stitch the images together. If you use a current version of Adobe Photoshop, then the Photomerge function is all you'll need. Some cameras come with free stitching software. This varies in quality, but is generally adequate. Commercial alternatives include Panoweaver and PTGui. You'll need to crop your image once it's been stitched. In terms of aspect ratio there's no right or wrong way to crop your image. However, using a "standard" panoramic aspect ratio such as 2:1 or 3:1 is a good starting point.

Note
Some cameras have an option to shoot "sweep" panoramics in which the camera is moved in one fluid movement and a panoramic image created in-camera. However, this is usually only available when shooting JPEG and often the resolution is limited.

CROPPED
The cropped image. This can be printed 1m across at 300ppi, which wouldn't have been possible if I'd cropped a standard 3:2 image to the same aspect ratio.

Close-up

The smaller the camera-to-subject distance, the less depth of field you'll be able to achieve. However, this isn't necessarily a bad thing. In this image, the out-of-focus background is less distracting and a better setting for the foreground fern than a sharper background would have been.

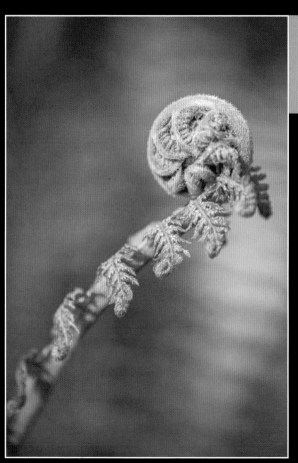

Nikon D600, 100mm macro lens, 1/250 sec. at f/4.5, ISO 100, Aperture priority mode, evaluative metering

Reflections

A reflection is not at the same distance as the medium it's reflected in. A reflection is essentially the same distance from the camera as the thing being reflected. This means that you have to use a small enough aperture to ensure that depth of field is sufficient to include both the reflection and the medium in which it is reflected.

Canon EOS 5D, 70–300mm lens at 70mm, 1/30 sec. at f/16, ISO 100, Aperture priority mode, evaluative metering

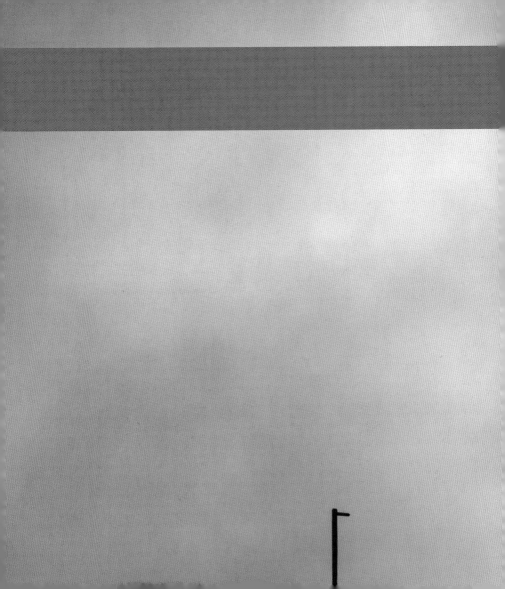

Postproduction

Postproduction, using image-editing software such as Adobe Photoshop, allows you to refine your vision for an image.

Keeping your options open

The key to successfully taking an idea from shooting through to the final image is never to unnecessarily restrict your options at any stage.

SNAPPED
This was just one of a number of "snaps" on a day out to a museum. However, I've grown to like it and so it's become a "keeper."

Unfortunately, it's easy to get this wrong from the very start. Shooting JPEG is the no-fuss option, the camera producing a ready-to-use image the moment the shutter button is pressed. However, many parameters such as contrast and white balance are "baked" into the image at this point too. This makes it less easy to unpick these later if you decide that they're not quite what you want. Shooting RAW, though it requires a commitment to postproduction, allows more flexibility in how an image is processed to produce a final result that matches your previsualization.

Another way to limit your options is to delete images that haven't "worked" as you shoot. Although images that are grossly under- or overexposed or out of focus are probably ripe for deletion, there may be images you delete that aren't worthy of such treatment. Some images are an immediate success, and some images you need to live with for a while before you begin to appreciate their potential. Unless memory card space is a critical issue, it's worth holding on to images for more considered appraisal in postproduction.

MONOCHROME *(Opposite)*
This image worked in color when I shot it. However, I could see it had potential as a black and white picture.

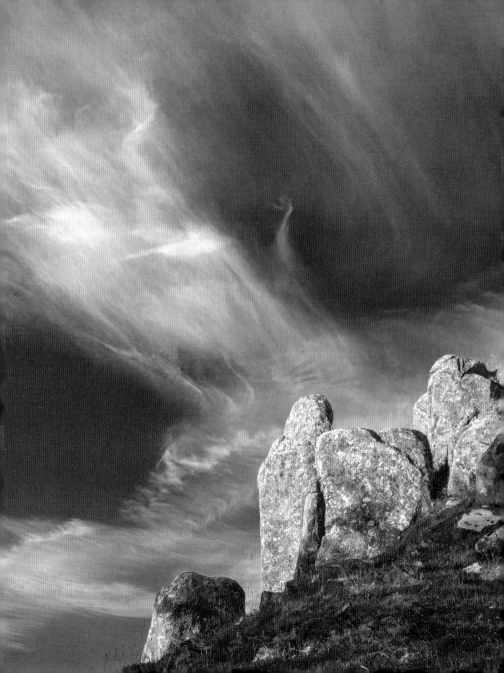

Tonal adjustment

Adobe Photoshop is the software package most associated with image processing. The techniques described on the following pages are designed to be used with Photoshop, but are also applicable to other packages that follow the Photoshop model.

Curves: lightening and darkening

There are a number of tools in Photoshop that allow you to lighten, darken, or add contrast to an image. There is no right or wrong tool to use and it's largely personal preference. However, arguably the most useful of Photoshop's tonal adjustment tools is Curves. It's the Swiss army knife of tools and can be used in various ways.

The main feature of Curves is the line running diagonally, from the top right corner of the central adjustment box (see right) to the bottom left (**1**). This line is the Input line. If you're wondering where curves come into this,

you can add control points to this line that can be pulled to turn it into a curve. Changing the shape of the Input line controls how the tones in the image are adjusted. Below the central adjustment box is the horizontal Input values strip (**2**). This represents the original distribution

PRE-ADJUSTMENT
This image has not been adjusted.

of tones in the image, from black on the far left to white on the far right.

Running vertically to the left of the central adjustment box is the Output value strip (**3**). This represents the degree to which the Input values will alter once the shape of the Input line is changed. Recent versions of Photoshop also show a histogram (**4**) within the adjustment box to show the distribution of tones in the image.

When the Input line is straight, the input and output values match. This indicates that no tonal adjustments have been made. To change the shape of the line click anywhere along its length to add a control point. If you move this control point up the Input value stays the same, but the Output value is increased. The Input tones below the control point (**5**) are altered in the image to match the Output tones to the left (**6**). This has the effect of lightening the picture (below). If the control point had been pulled down, the image would have darkened.

By adding more control points and moving these points you can make an increasingly complex curve that will alter different parts of the tonal range. By moving the black point (**7**) and white point (**8**) triangle below the Input values strip you can quickly set which tones in the image are darkened to pure black and lightened to white respectively. When you move the triangles, the end points of the curve above move in the same direction. You can also set the black, mid-tone, and white points of the curve by clicking on the relevant color picker below the Input values strip.

POST-ADJUSTMENT
By moving the control point upward the image is lightened. The tones closest in value to the Input value (in this case the mid-tones) are adjusted more than those further away (the tones at the extremes of the tonal range in this example).

Curves: contrast

You can add contrast to or remove it from an image using Curves. To add contrast create two control points on the Input line. Until you're happy with how the technique works, start with the control points equally spaced, one-third and two-thirds along the length of the line. Pull the higher control point up, see below (**1**), and the lower control point down (**2**). The Input line should now form an S shape (known rather fittingly as an S curve). The image will now have more contrast because the lighter tones have been lightened further and the darker tones darkened (the mid-tones will be relatively unaffected). The stronger the S shape, the greater the increase in contrast. To remove contrast add the two control points again, this time pulling the higher of the two down and the lower up. This time the lighter tones have been darkened and the darker tones lightened, bringing all the tones in the image closer to a mid-tone.

Curves: color balance

You can also use Curves to adjust the color balance of your images. The default setting of the **Channel** pop-up menu is **RGB** (meaning all colors are affected equally). However, when **Channel** is set to **Red**, **Green**, or **Blue** the curve that you create affects only the selected color channel. If you select **Blue**, for instance, you can add a blue tint to an image by adding a control point and moving the curve up. By moving the control point down, the amount of blue in the image is reduced, adding a red-green tint.

FLAT
This image was flat and lacking in contrast. By applying the S curve shown in the Curves dialog on this page, contrast was increased to create the image on the page opposite.

S CURVE

Nikon D600, 100mm macro lens, 2.5 sec. at f/18, ISO 100, Aperture priority mode, evaluative metering

The S curve is a very simple way to add contrast and bite to an image. By adding more control points it's possible to very finely tune specific parts of an image's tonal range.

Cropping

Cropping an image is a useful way to either reduce the size of an image or to reshape it to a new aspect ratio.

Improving an image

Although some cameras have an inbuilt crop facility, this is typically restricted for use with JPEG images and to a limited range of aspect ratios and sizes. Cropping in Photoshop allows more control over the cropping process. Cropping an image has a similar effect to adjusting the focal length. The more you crop, the more you "zoom" into the image. However, every time an image is cropped the pixel resolution of that image is reduced. Cropping excessively will therefore reduce the size an image can be printed without an unacceptable drop in image quality.

There are two main ways to precisely crop an image in Photoshop. You can either define a rectangular marquee selection or use the crop tool. The one you use is largely personal preference (you can also adjust the **Canvas Size**, but this is a slightly less intuitive way of cropping an image).

Marquee tool

 Photoshop's Marquee tools allow you to define an area referred to as a selection. The selected area is shown by a shimmering line (jokingly known as "marching ants"). Although we're going to use a selection to crop an image, they're more useful than that. You

can use a selection to choose an area of image that can be copied for pasting into a layer or into another image entirely. You can also use a selection to apply local adjustments to an image without affecting the area outside the selection.

When you define a selection for cropping you need to use the **Rectangular** marquee found on the Tool panel (you can't crop an image when a selection isn't perfectly rectangular).

To define a selection, left-click in the image at the point that you want to be the corner of the cropped image. Holding the mouse button down, drag the mouse pointer until you reach the opposite corner of the area you want to select. Once the selection has been set you can move it around the image by pressing the relevant cursor key. You can make the selection smaller by holding down alt and dragging a new selection so that it intersects with the first. You can also add to a selection in a similar fashion by holding down shift instead of alt.

You can constrain the shape of a selection before you define it. If you hold down shift as you drag the mouse, the selection will be constrained to a square shape rather than an arbitrarily shaped rectangle. To constrain the selection to a set aspect ratio set the pop-up **Style** menu on the Control panel to **Fixed**

Ratio. Change **Width** and **Height** to the required aspect ratio figures. As an example: if you enter in 4 to **Width** and 3 to **Height**, the selection will be constrained to an aspect ratio of 4:3, the same proportions as a Four Thirds image. To swap the figures around click on the double-arrow icon between **Width** and **Height**. If you make a mistake click anywhere outside the selected area to remove the selection.

Once the selection has been defined the image can be cropped. Select **Image > Crop** and the image will be cropped to the boundary of the selection.

Tip
You can't use a number larger than 999 in the Width and Height boxes next to style. If you want to use a figure greater than 1000, add a decimal point after the first digit (i.e. 1.000); make sure you do the same for the other value. If this is less than 1000, add a zero followed by a decimal point (i.e. 0.999).

CROPPED
Once cropped the area outside the selection is removed and the image re-shaped to the selected area.

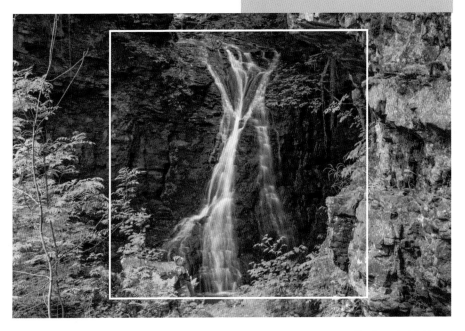

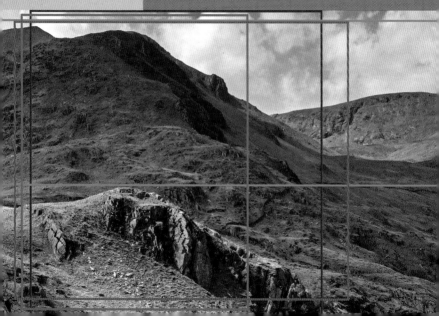

Canon EOS 5D, 50mm macro lens, 1/13 sec. at f/16, ISO 100, Aperture priority mode, evaluative metering

MULTIVIEW
With judicious cropping it's often possible to create several different images from the original file. This image could potentially be cropped one of four ways (if not more) to create a subtly different emphasis on the various parts of the landscape.

Crop tool

The Crop tool is superficially similar to the **Rectangular** marquee tool in that you define a box that delineates the area to be cropped. However, the crop tool selection is far easier to adjust, once you've created it, than the marquee tool: you can alter both the shape and the size of the cropping area by dragging the control handles on the edge of the selection box.

The cropping area can be constrained to a specific aspect ratio just like a marquee selection. However, unlike the marquee tool, you can also specify a new resolution for the image. This crops and adjusts the size of the image so that it is the correct size and shape for printing. To change the aspect ratio or resolution click on the **Original ratio** pop-up menu on the control panel (**Original ratio** is the default option and constrains the **Crop** selection to the same aspect ratio as the image).

You can display a grid inside the cropping area. This is a useful guide to the position of elements in the image post-cropping. The default grid is a mesh of small squares. You can also choose to show a grid that divides an image into thirds (making it easier to apply the "rule of thirds"), a "golden ratio", or a "golden spiral" (as well as other composition-related grid types). To change the grid type click on the grid pop-up on the control panel.

Note

*If you prefer to use Lightroom you can display a variety of grids when using the **Crop** tool by repeatedly pressing O (shift O rotates the grid).*

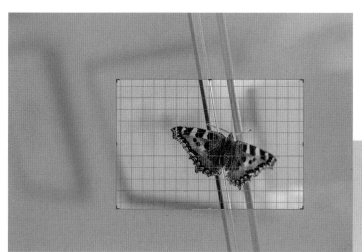

GRID
The grid option is a useful tool for judging the position of elements in the cropped image.

Finally, you can straighten an image as it is cropped. Select the spirit-level icon from the control panel and draw a line across or down the image. The image will then be rotated to that angle as it's cropped. Press return to crop the image once you're happy with the selection.

Perspective tool

 The **Perspective** tool is a variation of the **Crop** tool. You define an area just as with the **Crop** tool. Once the area has been defined you can move the corners so that the cropping area is no longer perfectly rectangular. When you press return, the selected area is distorted so that it becomes rectangular again. This is particularly useful for straightening out buildings that are no longer vertical in an image. As with the **Crop** tool, press return to crop the image once you're happy with the selection.

PERSPECTIVE
The key to successful use of the **Perspective** tool is not to use it to make large adjustments (top). Subtle alterations that don't distort the image too much are preferable (bottom).

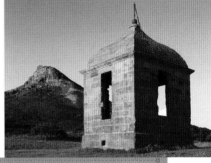

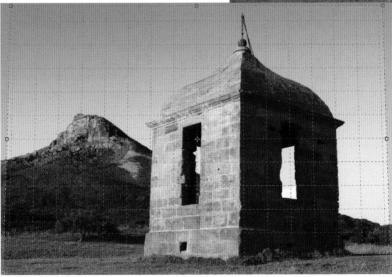

Where to crop

Knowing where to crop can be as involved a decision as the original composition. Care should be taken not to cut into important areas of the subject. You don't want to lose anything that's necessary to the structure or balance of the image. You should also be aware of space too. Leave room for your subject to breathe and don't crop too tightly (having elements in an image precisely touching the edges looks particularly odd).

Care should be taken when cropping images of people. There's something disconcerting about a crop that cuts across the joints of limbs.

If you have to crop a person's limbs try to keep the crop halfway between the joints. The same is true of facial features. Ears don't benefit from being cropped in half. Either crop the ears out entirely, so that you concentrate on the face, or leave space around the ears.

TIGHTER
A less contextual image than the original on the following page can be made by cropping in on the boy. The first attempt (left) is marred by cropping across the boy's ankle joint. The second attempt is better (right). It avoids cutting across the knee joints and, because less of the background is visible, it's a more focused image.

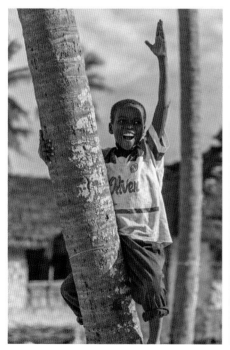
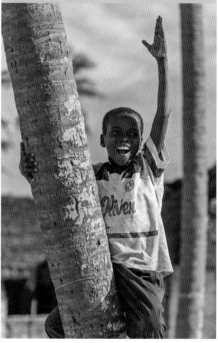

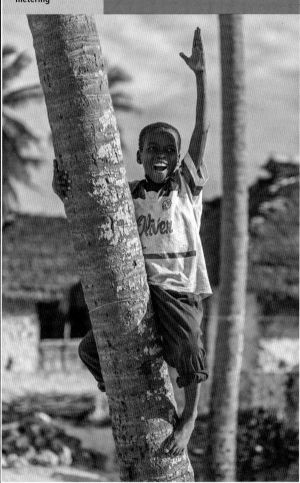

Canon EOS 5D, 100mm macro lens, 1/2000 sec. at f/3.5, ISO 200, Aperture priority mode, evaluative metering

CONTEXT
This is the uncropped image from the previous page. It's a contextual image. Although the subject is very much the young boy, there's enough background information to show the environment he's playing in (up to the camera).

Black & white

Once photographers could only work in black and white. Now it's very much a personal choice, but one that can be richly rewarding.

Reflectivity

It's easy to distinguish different objects by their color. A red object is visibly different to a blue one. However, convert those two objects to a black and white image and there may be little or no difference. The difference in the lightness or darkness of objects in a black and white image is determined by their reflectivity. The most extreme examples are those that reflect little or no light and so would be black, and those that reflect almost all the light that falls on them, making them white. Most objects fall somewhere in between these two extremes. If our red and blue objects had a similar reflectivity they would both be recorded as the same brightness of gray in the black and white image.

Traditionally, colored filters were used to separate color tonally when using black and white film. A colored filter lets through wavelengths of light similar in color to itself and blocks or reduces the strength of those on the opposite side of the color wheel. An orange filter lightens anything that's red-orange and darkens anything that's blue-green (and vice versa).

COLOR
When pure red and blue (left) are simply desaturated they become the same level of gray (center). By simulating an orange filter in the conversion process, red is lightened and blue darkened (right).

Nikon D600, 50mm lens, 1/100 sec. at f/5.6, ISO 1400, Aperture priority mode, evaluative metering

SYMPATHETIC

Black and white is a less literal medium than color photography. This means that there's arguably more scope for postproduction effects. However, the effects that are applied should still be sympathetic to your subject. This image suited a sepia tint. A cold, blue wash would have been less effective.

Digital black and white

Colored filters are typically no longer necessary when shooting digitally. Some cameras allow you to shoot in black and white. Some even allow you to simulate colored filters too. However, greater control is possible by shooting color and converting to black and white in postproduction.

There are a number of ways to convert to black and white using Photoshop. The simplest is the **Desaturate** filter. However, this isn't ideal and can produce flat-looking monochrome images. A better option is the relatively new **Black & White** filter. The filter mimics the use of colored filters, allowing you to adjust the brightness or darkness of individual colors when they're converted to monochrome.

1) Open your color image and then select **Image > Adjustments > Black & White** or add a **Black & White** adjustment layer.

2) Check the **Preview** button to view the initial black and white conversion. When **Auto** is selected Photoshop will analyze the image and convert it to monochrome based on range of colors in the image.

3) Although **Auto** works surprisingly well it's unlikely to produce an image exactly how you want it. For more control use the individual sliders to adjust how the various colors are converted. Moving a slider to the right will lighten a color, moving it to the left will darken it. You can save a particular arrangement of the sliders by clicking on the **Preset** icon to the right of the pop-up menu (or on the adjustment layer panel menu if you're using an adjustment layer). Select **Save** and enter a relevant file name.

4) Select **Tint** to add a color wash to your black and white image. **Hue** adjusts the color, **Saturation** adjusts the vibrancy of that color.

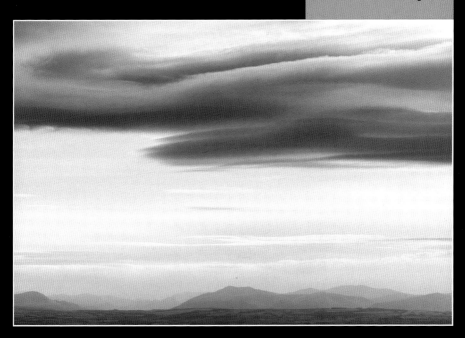

Nikon D600, 70–300mm lens at 110mm, 1/100 sec. at f//11, ISO 100, Aperture priority mode, evaluative metering

Vision

Ideally, postproduction should be used to fulfil your vision for an image, rather than to make a silk purse out of a sow's ear. I wanted this image to look coldly metallic to emphasize the mechanical nature of the subject.

Nikon D600, 50mm lens, 1/100 sec. at f/1.8, ISO 2800, Aperture priority mode, evaluative metering

Glossary

Aberration An imperfection in the image caused by the optics of a lens.

Additive color Color produced by light when it falls onto a surface. The three primary colors are red, green, and blue.

Aperture The opening in a camera lens through which light passes to expose the sensor. The relative size of the aperture is denoted by f-stops.

Aerial perspective Reduction in contrast and color saturation that increases with distance. Caused by dust and haze, it helps to convey a sense of depth.

Aspect ratio The proportion of an image's width to its height. Common standards include 3:2, the aspect ratio of a DSLR image, and 4:3, the aspect ratio of the Four Thirds system.

Bracketing Taking a series of identical pictures, changing only the exposure, usually in half or one f-stop (+/-) differences.

Buffer The memory of a digital camera.

Center-weighted metering A way of determining the exposure of a photograph, placing importance on the light-meter reading at the center of the frame.

Chromic aberration The inability of a lens to bring spectrum colors into focus at one point.

Color cast Unwanted color tinting either in a digital image or on a print.

Color gamut The range of hues a digital device such as a monitor or printer can reproduce.

Color temperature The color of a light source expressed in degrees Kelvin (°K).

Compression The process by which digital files are reduced in size. Compression can retain all the information in the file, or "lose" data usually in the form of fine detail for greater levels of file-size reduction.

Contrast The range between the highlight and shadow areas of an image, or a marked difference in illumination between colors or adjacent areas.

Converging The effect, either real or implied, of lines coming closer together in an image.

Crop To trim an image, either to reduce it in size proportionally or to reshape it for aesthetic reasons.

Depth of field (DOF) The amount of an image that appears acceptably sharp. This is controlled by the aperture: the smaller the aperture, the greater the depth of field.

DPOF Digital Print Order Format.

Diopter Unit expressing the power of a lens.

dpi (dots per inch) Measure of the resolution of a printer or scanner. The more dots per inch, the higher the resolution.

Dynamic range The ability of the camera's sensor to capture a full range of shadows and highlights.

Evaluative metering A metering system whereby light reflected from several subject areas is calculated based on algorithms.

Exposure The amount of light allowed to hit the sensor, controlled by aperture, shutter speed, and ISO. Also, the act of taking a photograph, as in "making an exposure."

Exposure compensation A control that allows intentional over- or underexposure.

Filter A piece of colored, or coated, glass or plastic placed in front of the lens.

Focal length The distance, usually in millimeters, from the optical center point of a lens element to its focal point.

f-stop Number assigned to a particular lens aperture. Wide apertures are denoted by small numbers such as f/2; and small apertures by large numbers such as f/22.

Histogram A graph used to represent the distribution of tones in an image.

Hotshoe An accessory shoe with electrical contacts that allows synchronization between the camera and a flashgun (or other compatible device).

Hue A specific color such as red or blue.

Interpolation A way of increasing the file size of a digital image by adding pixels, thereby increasing its resolution.

HDMI High Definition Multimedia Interface.

ISO (International Organization for Standardization) The sensitivity of the sensor measured in terms equivalent to the ISO rating of a film.

Joiner The technique of creating an image from a large number of smaller images.

JPEG (Joint Photographic Experts Group) JPEG compression can reduce file sizes to about 5% of their original size.

Landscape Orientation of an image where the width is greater than the height. Less confusingly referred to as horizontal.

Leading line A line, either real or implied, that helps to direct a viewer's gaze through a picture.

LCD (liquid crystal display) The flat screen on a digital camera that allows the user to compose and review digital images.

Macro A term used to describe close-focusing and the close-focusing ability of a lens.

Megapixel One million pixels equals one megapixel.

Memory card A removable storage device for digital cameras.

Neutral gray Gray that has no color tinting.

Noise Colored image interference caused by stray electrical signals.

PictBridge The industry standard for sending information directly from a camera to a printer, without having to connect to a computer.

Pixel Short for "picture element"—the smallest bits of information in a digital image.

Placement The position of the main subject or subjects within the image space

Portrait Orientation of an image where the height is greater than the width. Less confusingly referred to as vertical.

Postproduction Adjusting an image after shooting using software such as Photoshop or Lightroom.

RAW The file format in which the raw data from the sensor is stored without permanent alteration being made.

Resolution The number of pixels used to capture or display an image.

RGB (red, green, blue) Computers and other digital devices understand color information as combinations of red, green, and blue.

Rule of thirds A rule of thumb that places key elements of a picture at points along imagined lines dividing the frame into thirds.

Shutter The mechanism that controls the amount of light reaching the sensor, by opening and closing.

Subtractive color Color produced by light reflecting from a surface.

Telephoto A lens with a large focal length and a narrow angle of view.

TTL (through the lens) metering A metering system built into the camera that measures light passing through the lens at the time of shooting.

TIFF (Tagged Image File Format) A universal file format supported by virtually all relevant software applications. TIFFs are uncompressed digital files.

USB (universal serial bus) A data transfer standard, used by most cameras when connecting to a computer.

Viewfinder An optical system used for composing, and sometimes for focusing the subject.

Vignette Specific term in printing to fade an image to white around the edges.

White balance A function that allows the correct color balance to be recorded for any given lighting situation.

Wide-angle lens A lens with a short focal length and consequently a wide angle of view.

Useful web sites

EQUIPMENT

Adobe
www.adobe.com

Canon (Global)
www.canon.com

FujiFilm (Global)
www.fujifilm.com

Nikon (Global)
www.nikon.com

Olympus (Global)
www.olympus-global.com

Panasonic (Global)
www.panasonic.net

Pentax (Global)
www.pentax.jp/english/globalsites

Ricoh (Global)
www.ricoh.com

Sigma (Global)
www.sigma-photo.co.jp/english/network

Sony (US)
www.sony.com

Sony (UK)
www.sony.co.uk

Tamron (Global)
www.tamron.com

Tokina
www.tokinalens.com

GENERAL

David Taylor
Landscape and travel photography
www.davidtaylorphotography.co.uk

Photo.Net
Photography community and resource web site
photo.net

On Landscape
Online British landscape photography
magazine
www.onlandscape.co.uk

Digital Photography Review
Camera and lens review site
www.dpreview.com

PHOTOGRAPHY PUBLICATIONS

Photography books & Expanded Camera Guides
www.ammonitepress.com

***Black and White Photography* magazine**
***Outdoor Photography* magazine**
www.thegmcgroup.com

Index

Understanding Composition
THE EXPANDED GUIDE

APS-C DSLR with 17mm focal length (approx. 28mm angle of view equivalent)

SUBJECT DISTANCE FEET	f/4 Near	f/4 Far	f/5.6 Near	f/5.6 Far	f/8 Near	f/8 Far	f/11 Near	f/11 Far	f/16 Near	f/16 Far
100	11.1	∞	8.1	∞	5.9	∞	4.2	∞	3	∞
50	10	∞	7.5	∞	5.5	∞	4	∞	2.9	∞
25	8.3	∞	6.5	∞	5	∞	3.8	∞	2.8	∞
12	6.1	282	5.1	∞	4.1	∞	3.2	∞	2.5	∞
6	4	11.5	3.5	18.4	3	127	2.6	∞	2	∞
3	2.4	3.9	2.2	4.5	2	5.7	1.8	9	1.5	53.6

SUBJECT DISTANCE METERS	f/4 Near	f/4 Far	f/5.6 Near	f/5.6 Far	f/8 Near	f/8 Far	f/11 Near	f/11 Far	f/16 Near	f/16 Far
30	3.4	∞	2.5	∞	1.8	∞	1.3	∞	0.92	∞
15	3	∞	2.3	∞	1.7	∞	1.2	∞	0.9	∞
8	2.6	∞	2	∞	1.5	∞	1.1	∞	0.8	∞
4	1.9	∞	1.6	∞	1.3	∞	1	∞	0.77	∞
2	1.3	4.2	1.2	7.6	1	∞	0.8	∞	0.6	∞
1	0.8	1.3	0.7	1.6	0.7	2	0.6	3.7	0.5	∞

APS-C DSLR with 35mm focal length (approx. 50mm angle of view equivalent)

SUBJECT DISTANCE FEET	f/4 Near	f/4 Far	f/5.6 Near	f/5.6 Far	f/8 Near	f/8 Far	f/11 Near	f/11 Far	f/16 Near	f/16 Far
100	35	∞	27.2	∞	21	∞	15.8	∞	11.7	∞
50	26	800	21.4	∞	17.3	∞	13.6	∞	10.5	∞
25	17	47	15	75	13	425	10.7	∞	8.7	∞
12	10	15	9.1	18	8.3	22	7.3	33	6.3	119
6	5.4	6.7	5.2	7.1	4.9	7.7	4.6	8.8	4.1	10.8
3	2.8	3.1	2.8	3.2	2.7	3.4	2.6	3.5	2.5	3.8

SUBJECT DISTANCE METERS	f/4 Near	f/4 Far	f/5.6 Near	f/5.6 Far	f/8 Near	f/8 Far	f/11 Near	f/11 Far	f/16 Near	f/16 Far
30	10.5	∞	8.3	∞	6.4	∞	4.8	∞	3.6	∞
15	7.8	209	6.5	∞	5.2	∞	4.1	∞	3.2	∞
8	5.3	15.8	4.7	26.6	4	684	3.3	∞	2.7	∞
4	3.2	5.3	3	6.1	2.7	7.9	2.3	13.1	2	249
2	1.8	2.3	1.7	2.4	1.6	2.7	1.5	3	1.3	3.9
1	0.9	1	0.9	1.1	0.89	1.14	0.9	1.2	0.8	1.3

HYPERFOCAL DISTANCE TABLES

Full-frame DSLR with 28mm focal length

SUBJECT DISTANCE FEET	f/4 Near	f/4 Far	f/5.6 Near	f/5.6 Far	f/8 Near	f/8 Far	f/11 Near	f/11 Far	f/16 Near	f/16 Far
100	17.7	∞	13.2	∞	9.7	∞	7	∞	5	∞
50	15	∞	11.6	∞	8.8	∞	6.6	∞	4.8	∞
25	11.6	∞	9.5	∞	7.5	∞	5.8	∞	4.4	∞
12	7.7	∞	6.7	∞	5.7	∞	4.7	∞	3.7	∞
6	4.7	8.3	4.3	9.8	3.9	13.4	3.4	27	2.8	∞
3	2.6	3.5	2.5	3.7	2.3	4.1	2.2	4.9	1.9	6.5

SUBJECT DISTANCE METERS	f/4 Near	f/4 Far	f/5.6 Near	f/5.6 Far	f/8 Near	f/8 Far	f/11 Near	f/11 Far	f/16 Near	f/16 Far
30	5.4	∞	4	∞	2.9	∞	2.1	∞	1.5	∞
15	4.6	∞	3.5	∞	2.7	∞	2	∞	1.4	∞
8	3.6	∞	2.9	∞	2.3	∞	1.8	∞	1.3	∞
4	2.5	10.2	2.1	28.5	1.8	∞	1.5	∞	1.2	∞
2	1.5	2.9	1.4	3.5	1.2	5	1	13.7	0.9	∞
1	0.9	1.2	0.8	1.3	0.77	1.4	0.7	1.7	0.6	2.5

Full-frame DSLR with 50mm focal length

SUBJECT DISTANCE FEET	f/4 Near	f/4 Far	f/5.6 Near	f/5.6 Far	f/8 Near	f/8 Far	f/11 Near	f/11 Far	f/16 Near	f/16 Far
100	40.6	∞	32.6	∞	25.5	∞	19.5	∞	14.6	∞
50	28.9	185	24.6	∞	20.3	∞	16.3	∞	12.8	∞
25	18.3	39.3	16.5	51.4	14.5	91.5	12.3	∞	10.2	∞
12	10.2	14.5	9.6	15.9	8.9	18.4	8	23.5	7	39
6	5.5	6.6	5.3	6.8	5.1	7.2	4.8	7.9	4.5	9.1
3	2.9	3.1	2.8	3.2	2.8	3.3	2.7	3.4	2.6	3.6

SUBJECT DISTANCE METERS	f/4 Near	f/4 Far	f/5.6 Near	f/5.6 Far	f/8 Near	f/8 Far	f/11 Near	f/11 Far	f/16 Near	f/16 Far
30	12.3	∞	9.9	∞	7.7	∞	5.9	∞	4.4	∞
15	8.7	53	7.4	∞	6.2	∞	4.9	∞	3.8	∞
8	5.8	12.9	5.2	17.4	4.5	33.8	3.8	∞	3.1	∞
4	3.4	4.9	3.1	5.5	2.9	6.4	2.6	8.6	2.3	16.6
2	1.8	2.2	1.77	2.3	1.6	2.5	1.5	2.7	1.5	3.2
1	0.96	1.05	0.94	1.07	0.92	1.1	0.9	1.15	0.8	1.2